Exhibitionism: 50 Years of The Museum at FIT

EXHIBITIONISM

50 Years
of The Museum
at FIT

Edited by
Valerie Steele and Colleen Hill

SKIRA

Cover
Poster dress by Harry Gordon,
paper dress, England, 1968

Design
Marcello Francone

Editorial Coordination
Emma Cavazzini

Editing
Anna Albano

Layout
Barbara Galotta

Photo Credits
Photographs © The Museum
at FIT

First published in Italy in 2018 by
Skira editore S.p.A.
Palazzo Casati Stampa
via Torino 61
20123 Milano
Italy
www.skira.net

© 2018 The Museum at FIT,
Fashion Institute of Technology,
New York
© 2018 The Authors
for their texts
© 2018 Skira editore
for this edition

Printed and bound in Italy.
First edition

ISBN: 978-88-572-3972-9

Distributed in USA, Canada,
Central & South America
by ARTBOOK | D.A.P. 75,
Broad Street Suite 630,
New York, NY 10004, USA.
Distributed elsewhere in the
world by Thames and Hudson
Ltd., 181A High Holborn, London
WC1V 7QX, United Kingdom.

Acknowledgments

We extend our sincere thanks to
Dr. Joyce F. Brown, President of
the Fashion Institute of Technology,
for her support. Thanks also to the
members of the Couture Council of
The Museum at FIT, whose generosity
strengthens our exhibitions and public
programs. Likewise, we are grateful
to the FIT Foundation, the Office
of Communications and External
Relations, and all of our other partners.
This book honors the work
of The Museum at FIT staff, past
and present, who have made possible
such a diverse, dynamic, and
significant array of exhibitions. We
would like to extend special thanks
to the contributing authors to this
publication: Faith Cooper, Fred Dennis,
Melissa Marra, Emma McClendon,
Michelle McVicker, Patricia Mears,
Tanya Melendez, and Elizabeth Way.
We are also indebted to The Museum
at FIT photographer, Eileen Costa, as
well as our digital media team, Tamsen
Young and Oyinade Koyi, for providing
the photographs that document and
highlight our history. Julian Clark,
Publications Coordinator at The
Museum at FIT, provided his invaluable
editing skills to this text, and graphic
designer Gretchen Ervin has helped to
shape this project's visual identity. Our
sincerest thanks to our colleagues at
Skira: Anna Albano, Emma Cavazzini,
Marcello Francone, Barbara Galotta,
and Edoardo Ghizzoni.

Valerie Steele and Colleen Hill,
October 2018

Contents

Introduction

Exhibitionism: 50 Years of The Museum at FIT celebrates the 50th anniversary of "the most fashionable museum in New York City." Founded in 1969 by the Fashion Institute of Technology, The Museum at FIT is a specialized fashion museum best known for its innovative and award-winning exhibitions. Over the fifty years of its existence, the museum has presented approximately 200 fashion exhibitions. In this book, we have chosen to focus on some of the most interesting and influential ones, such as *Fashion and Surrealism* (1987), a groundbreaking show that explored the relationship between art and fashion; *The Corset: Fashioning the Body* (2000), a compelling exploration of the most controversial garment in fashion history; and *Fairy Tale Fashion* (2016), a magical look at such enchanted and emblematic items as the glass slipper and the red riding hood.

Robert Riley was the founding director of what was initially known as the Design Laboratory at FIT; he had previously been curator of the Brooklyn Museum's Design Laboratory. From the beginning, Riley worked to build a great collection at FIT. Although some of it was borrowed from the Brooklyn Museum, much of it became part of FIT's permanent collection. Once a dedicated building was constructed encompassing The Galleries at FIT, Riley started organizing exhibitions,

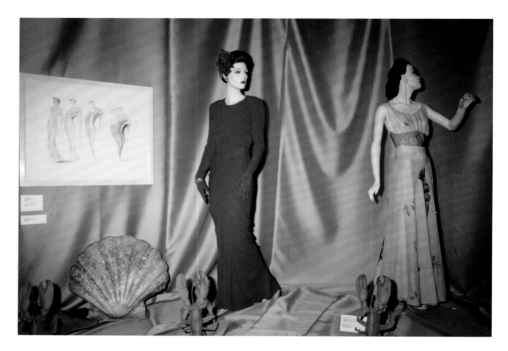

such as *Paul Poiret, The King of Fashion* (1976) and *Givenchy: Thirty Years* (1982).

Richard Martin, Laura Sinderbrand, and Harold Koda put the Design Laboratory and the Galleries at FIT on the map in the 1980s and early 1990s, with exhibitions like *Fashion and Surrealism* (1987), *Three Women* (1987), *Jocks and Nerds* (1989), *Halston: Absolute Modernism* (1992), and *Versace* (1992). After Richard and Harold moved uptown to the Costume Institute, Dorothy Twining Globus was appointed director of what was now renamed The Museum at FIT. She tilted the museum away from fashion and toward the decorative arts in general. In 1997 I joined The Museum at FIT, where I was appointed director in 2003, leading the museum to its core mission: to educate and inspire diverse audiences with innovative exhibitions and programs that advance knowledge of fashion. Whether monographic (like *Madame Grès: Sphinx of Fashion*), chronological (*Elegance in an Age of Crisis: Fashions of the 1930s*), or thematic (*Japan Fashion Now)*, MFIT's exhibitions contextualize fashion and underscore its connections to history, culture, and society. Ambitious exhibitions, such as *A Queer History of Fashion: From the Closet to the Catwalk* (2013), are accompanied by both a publication and an international symposium.

In addition to the Special Exhibitions Gallery, MFIT established a Fashion History Gallery, which exclusively

◀ Installation view of *Fashion and Surrealism* featuring *La Sirène* dress by Charles James and *Lobster* dress by Elsa Schiaparelli and Salvador Dalí

▶ A selection of contemporary menswear featured in *Japan Fashion Now*

▶ The *Fairy Tale Fashion* exhibition illustrating *Rapunzel* with a curtain by Nicolette Brunklaus and dress by Alexander McQueen

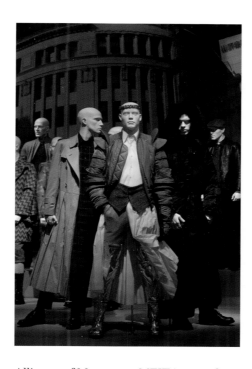

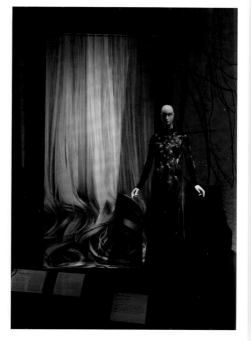

utilizes MFIT's permanent collection, consisting of more than 50,000 garments and accessories from the eighteenth century to the present. Exhibitions organized in this gallery include *Black Fashion Designers* (2017), *Force of Nature* (2017), and *The Body: Fashion and Physique* (2018). There is also a third, smaller, space, Gallery FIT, that is used for student exhibitions, including an annual exhibition organized with MA students from FIT's Fashion and Textile Studies department. Beginning next year, MFIT will also organize an annual exhibition with MFA students in Fashion Design.

As one of the rare college and university museums to receive accreditation from the American Alliance of Museums, MFIT is proud of its commitment to education. Each year, several hundred classes and tours take place in the museum, serving FIT students, as well as students from many other schools and universities. *Exhibitionism* also includes essays about fashion education in the museum, highlighting MFIT's symposia and Fashion Culture programming, as well as the role of hands-on, object-based learning utilizing the museum's Study Collection.

MFIT's 50th anniversary offers an ideal opportunity to document and celebrate the museum's past and prepare for its future. The topic of this publication is inherently unique, as it relies on the museum's own history. By conducting thorough research into MFIT's past, *Exhibitionism* will contribute to a growing body of scholarship on the topic of fashion collections and exhibitions. The history of the museum is also an integral part of the history of FIT, which is celebrating its 75th anniversary in 2019.

The staff of The Museum at FIT would like to thank all of our colleagues at the college for their welcome collaboration, especially President Joyce F. Brown. None of these exhibitions would have been possible without the individuals, foundations, and corporations that helped support us. In particular, we would like to thank the members of the Couture Council of The Museum at FIT for their generosity. **Valerie Steele**

Adrian Retrospective

May 17, 1971
Organizer: Robert Riley

FIT's 1971 retrospective on Hollywood costume and fashion designer Gilbert Adrian was not, in fact, an exhibition—it was a live runway show. Organized by Robert Riley to raise money for student scholarships, it featured more than two-hundred garments borrowed from private lenders and institutions across the United States. Upon hearing about the event, Metro-Goldwyn-Mayer unearthed movie costumes that Adrian had designed for Joan Crawford, Greta Garbo, Jean Harlow, and other stars. These were donated to FIT, where they remain as treasured items in the museum's collection.

It was not only Adrian's movie costumes that drew a crowd of more than 800 guests, but also his beautiful day suits, known for their padded shoulders, fitted waists, and slim skirts. The models who showcased the garments—specially selected to fit Adrian's 5'9, broad-shouldered ideal—danced down the catwalk, demonstrating what Bill Cunningham described as a "vivid championing for an American talent." The Museum at FIT collection now includes more than one hundred garments and accessories by Adrian, and the designer's work has been prominently featured in exhibitions such as *American Beauty* (2009) and the graduate student exhibition *Adrian: Hollywood and Beyond* (2017). **Colleen Hill**

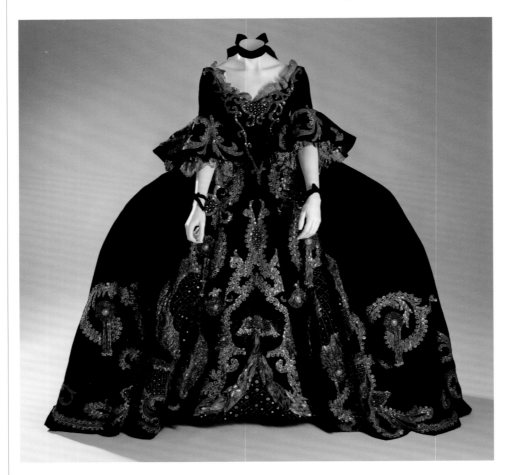

◄ Adrian, film costume
for Gladys George in *Marie
Antoinette*, USA, 1938

▼ Adrian, film costume
for Joan Crawford in *The Bride
Wore Red*, USA, 1937

▼ Adrian, suit, USA, c. 1946

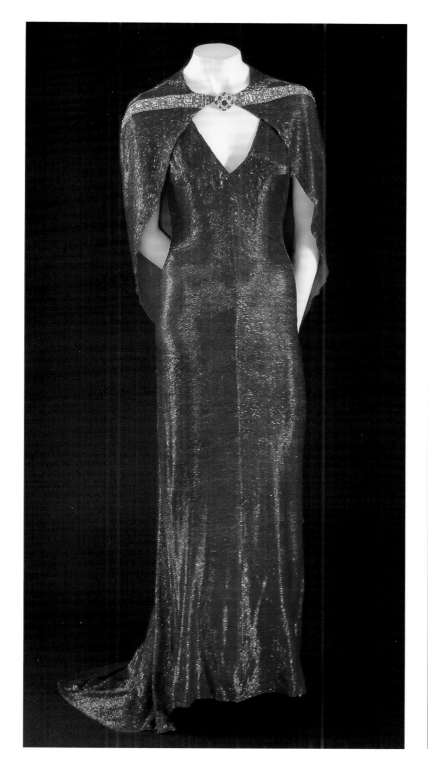

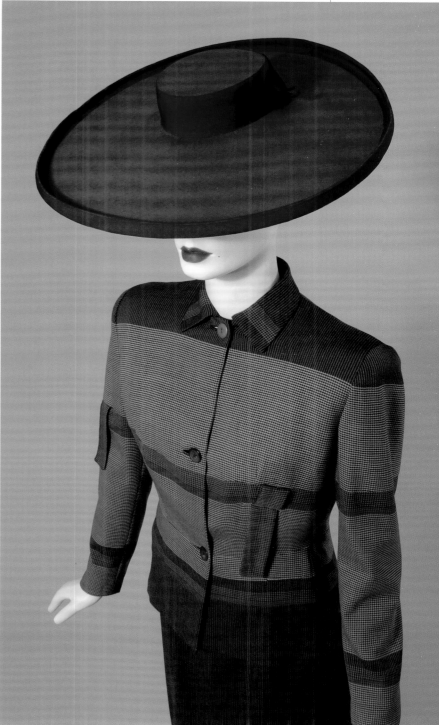

Paul Poiret, King of Fashion

May 25 – September 11, 1976
Curator: Robert Riley

In 1970, Robert Riley, director of the Design Laboratory at FIT, returned from a visit to Paris, and announced that he had met Paul Poiret's widow, Denise, and now he wanted to organize an exhibition of her late husband's work. His colleagues were puzzled: who was Paul Poiret? The revolutionary designer of the early twentieth century, once famous for abolishing the corseted silhouette, had been forgotten. That would change in 1976 with the exhibition *Paul Poiret, King of Fashion*. The exhibition featured more than 75 looks, some loaned by Denise Poiret, others by the Musée du Costume de la Ville de Paris, and the Union Française des Arts du Costume, as well as various American museums. The Design Laboratory at FIT was also acquiring its own collection of Poirets. At Robert Riley's suggestion, Mrs. Katharine Colton donated a "Persian" masquerade costume (1919) and a green brocade evening gown (c. 1920) that had been worn by her mother, Mrs. Henry Clews.

The exhibition's success owed much to its design by Marty Bronson, director of The Galleries at FIT. There were three galleries but in the center of the main gallery was a recreation of Poiret's famous 1002 Night Ball, which Bill Cunningham described as "a revolution in the soaring heights of display wizardry. The famed Faubourg St. Honoré garden of the designer's house is magically recaptured in the 3,260 square feet of the gallery." Since both Paul Poiret's and Denise Poiret's original masquerade costumes had disappeared, they were replaced by a replica and by Mrs. Clews' costume, which Poiret had designed several years after his own fête.

Valerie Steele

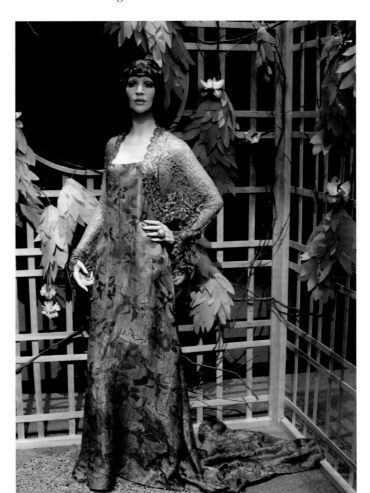

◀ Evening gown, c. 1920, worn by Mrs. Henry Clews

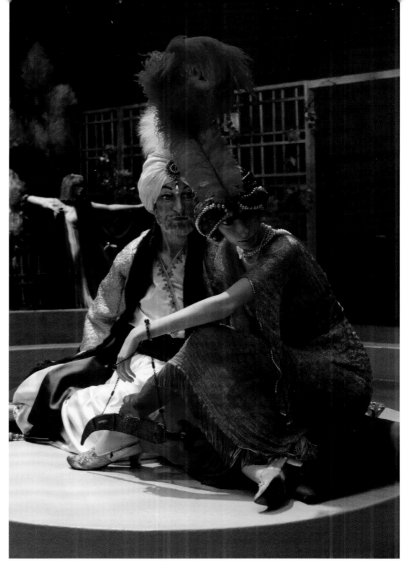

▶ Mrs. Clews' Persian masquerade costume, 1919, which replaced Denise Poiret's lost costume

▼ The center gallery, designed by Marty Bronson

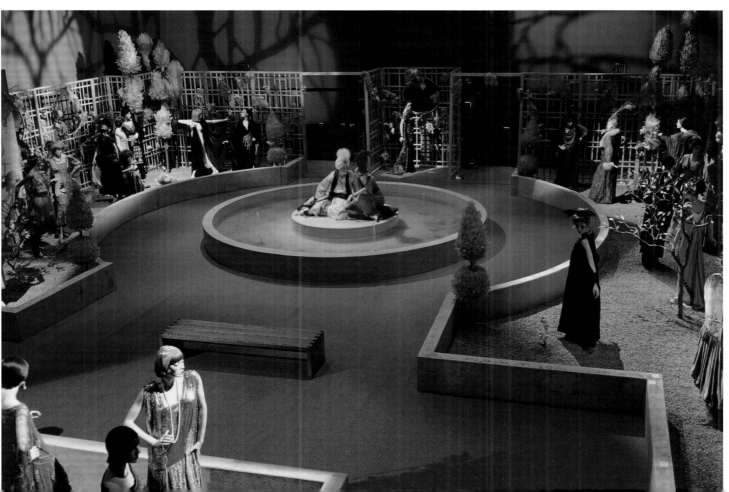

Givenchy: Thirty Years

May 11 – October 2, 1982
Curators: Hubert de Givenchy and Laura Sinderbrand

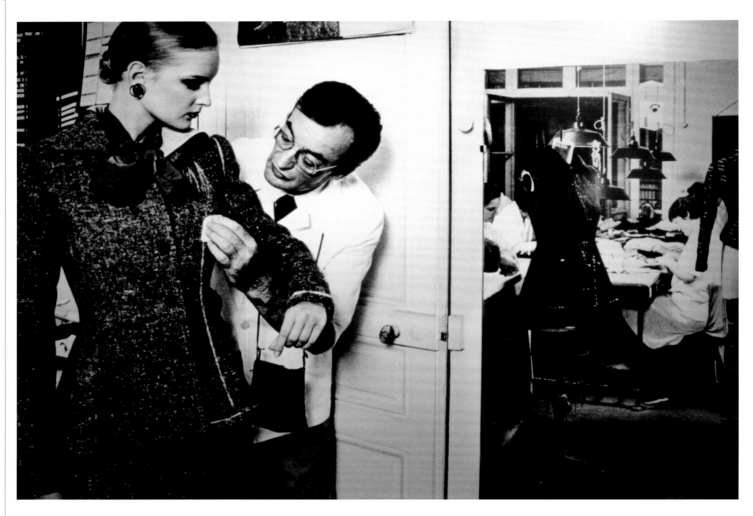

The French couturier Hubert de Givenchy was the subject of a major retrospective at FIT in 1982. *Givenchy: Thirty Years* featured almost 100 garments, including many loaned by illustrious clients such as Audrey Hepburn, Princess Grace of Monaco, the Duchess of Windsor, and Mrs. Paul Mellon. The garments were chosen by the designer in consultation with Laura Sinderbrand, Director of the Edward C. Blum Design Laboratory at FIT.

The gala opening was co-chaired by Marvin Traub of Bloomingdale's and Givenchy's muse, Audrey Hepburn. There was also a live fashion show of Givenchy's most recent couture collection, and Bloomingdale's sold a special line of Givenchy styles. A year later, the Yves Saint Laurent retrospective opened at the Costume Institute of the Metropolitan Museum of Art, which received so much criticism that the Metropolitan Museum banned fashion exhibitions devoted to a single living designer (a ban that lasted until 2017). Clearly fashion in an art museum aroused controversy, which it did not at a school like FIT.

Valerie Steele

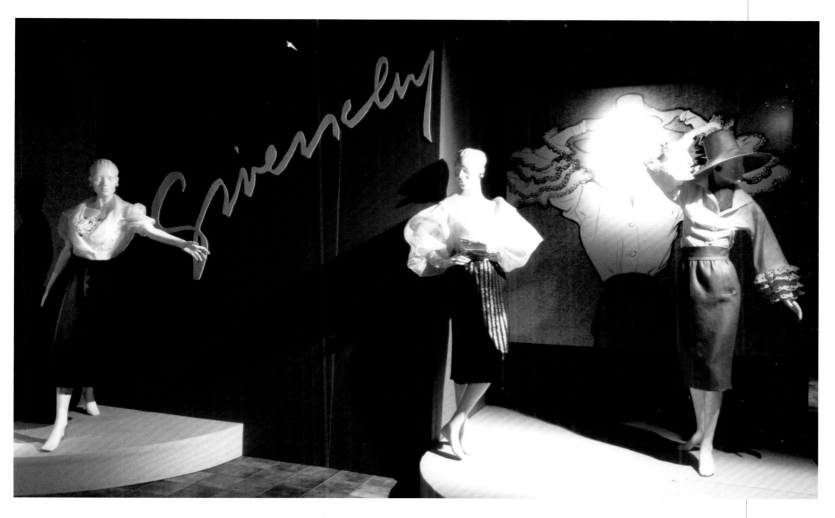

◄ Hubert de Givenchy fitting
a client in his atelier

▲ Some of the ensembles
featured in the exhibition

Three Women

February 24 – April 18, 1987
Curators: Richard Martin and Harold Koda

Three Women (1987) was one of the most important exhibitions mounted at the FIT Galleries. Not a retrospective, it brilliantly juxtaposed the work of three women who redefined fashion: 1) Madeleine Vionnet, a French couturière whose body-worshipping gowns revolutionized fashion in the 1910s, 20s, and 30s; 2) Claire McCardell, a New York ready-to-wear designer whose advanced sportswear epitomized the American Look of the 1940s and 50s; and 3) Rei Kawakubo of Comme des Garçons, an avant-garde Japanese designer whose radical, deconstructed clothes transformed fashion in the 1980s.

Laura Sinderbrand, then director of the Design Laboratory, recalled that she was talking with Richard Martin, executive director of the Shirley Goodman Resource Center at FIT, and Harold Koda, curator of costume, about the fact that FIT students did not seem familiar with the work of Rei Kawakubo, when "Someone said she was the Vionnet and Claire McCardell of her time, and suddenly we hit on the theme for the exhibition." Kawakubo participated actively in the creation of the exhibition, together with Kazuko Koike, curator of the Kawakubo Gallery, and Takaaki Matsumoto, who designed the exhibition and catalog. According to the short, unsigned catalog text: "these women make clothes that make women …. Their analytical considerations of construction, of the body, and of the social role of women were and are brave and abiding ideas about fashion." Seeing *Three Women*, I was inspired to research and write my book, *Women of Fashion: Twentieth-Century Designers*. **Valerie Steele**

▼ Rei Kawakubo installation

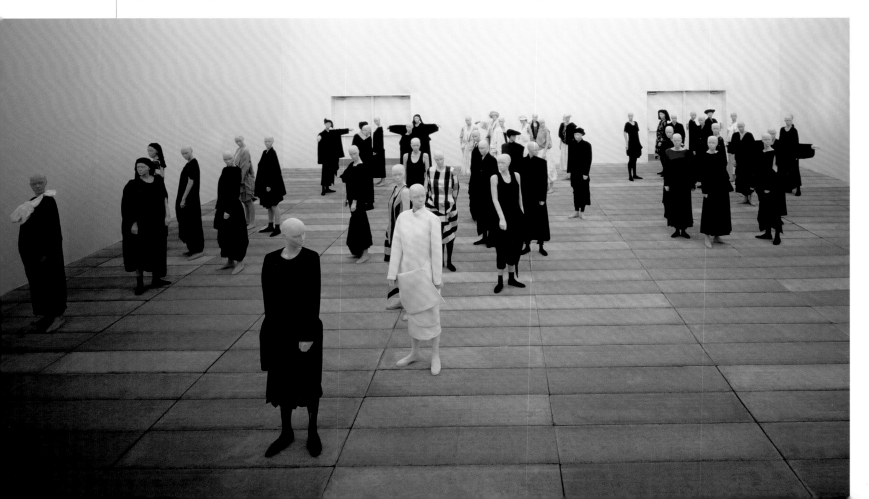

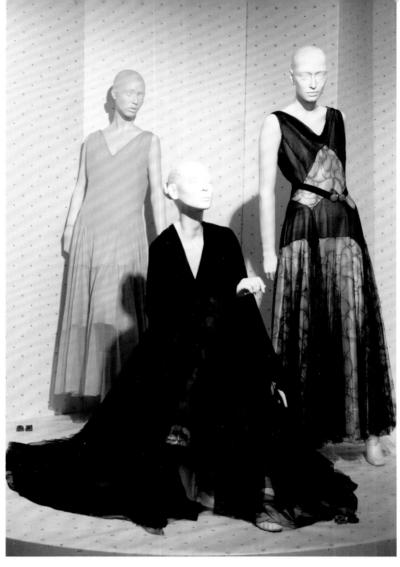

▼ Claire McCardell installation ▶ Vionnet dresses

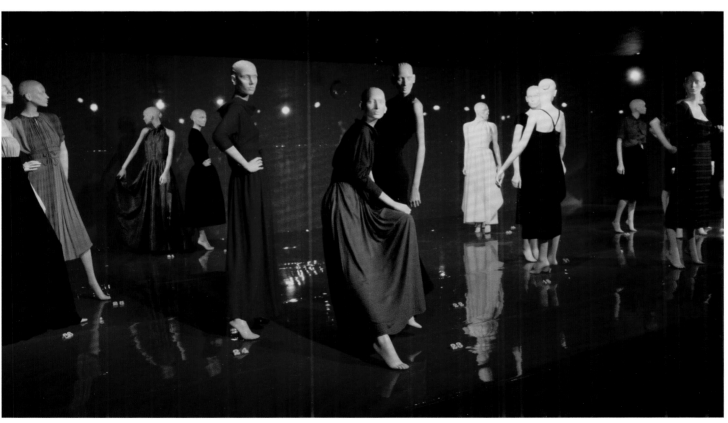

Fashion and Surrealism

October 30, 1987 – January 23, 1988
Curators: Richard Martin, Laura Sinderbrand, and Harold Koda

Fashion and Surrealism was one of FIT's most popular and influential exhibitions. Organized by Richard Martin, Laura Sinderbrand, and Harold Koda, with exhibition design by Stephen Pietri, it featured a wide range of historic and contemporary fashions inspired by Surrealism. There were also Surrealist paintings, furniture, photographs, and mannequins by artists such as Salvador Dalí.

"The Surrealist preoccupation with the body ... lends itself to fashion," said Martin, adding: "Fashion is where Surrealism still lives." Other key Surrealist tropes were body parts and transformation, so there were hats in the shape of shoes, shoes in the shape of feet, and a number of garments featuring disembodied eyes, which have always been a popular motif in the Surrealist lexicon.

Other highlights included a red *La Sirène* dress by Charles James and the famous lobster dress by Elsa Schiaparelli and Salvador Dalí, cleverly juxtaposed with sketches by Antonio depicting a woman in a red dress transforming into a high-heeled shoe.
Martin wrote the accompanying book, *Fashion and Surrealism* (Rizzoli), which greatly extended the exhibition's afterlife. **Valerie Steele**

▶ The cover of the *Fashion and Surrealism* book by Richard Martin, with an image from a 1986 issue of *The Face* magazine, by Tony Viramontes

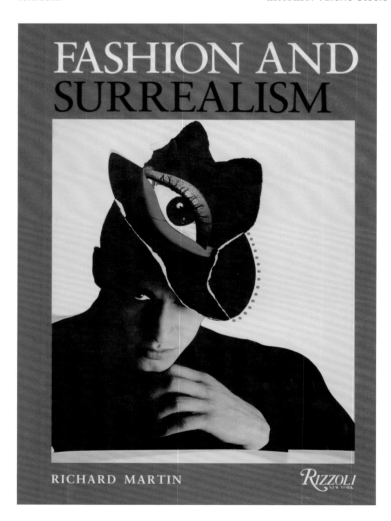

► The *Tear* dress by Elsa Schiaparelli and Salvador Dalí

▼ A hand-painted suit by Larry Shox and a paper dress by Harry Gordon

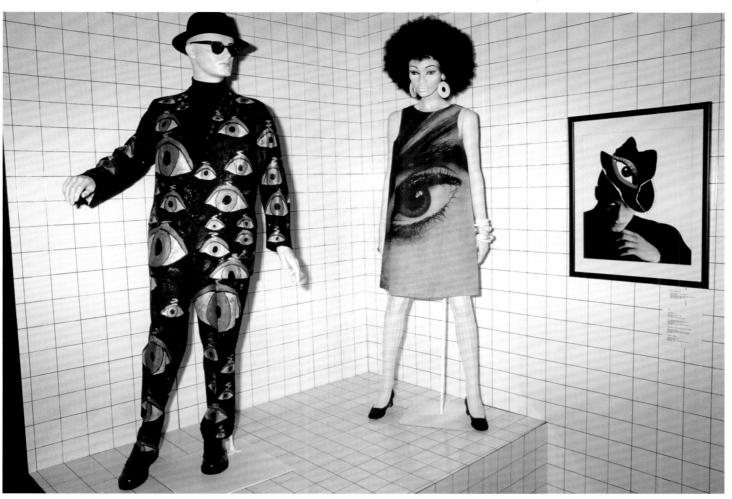

Jocks and Nerds: Men's Style in the Twentieth Century

April 4 – May 6, 1989
Curators: Richard Martin and Harold Koda

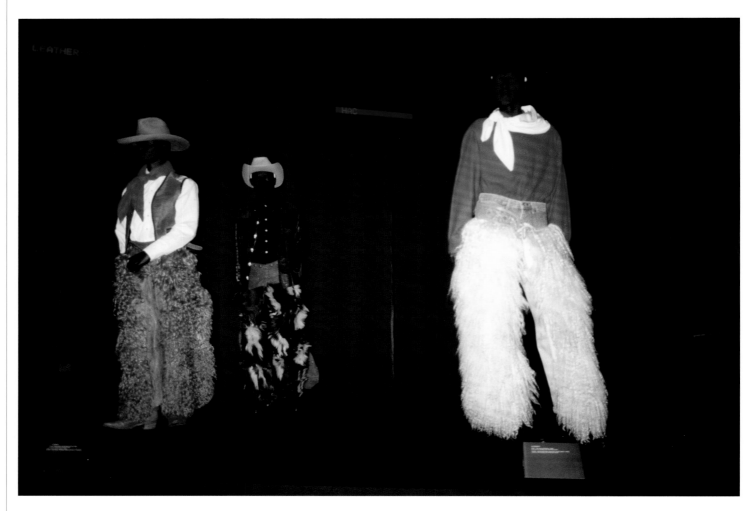

Pioneering curator Richard Martin was a conceptual thinker whose expansive investigations advanced the fields of fashion studies and curation. He organized this visual "proposition about the way men dress in the twentieth century" more than a decade before the year 2000. Like its playful title, both the exhibition and the accompanying book were not strictly limited in either time or scope.

One dozen "types," not just jocks (powerful athletes) or nerds (socially awkward brainiacs), populated the exhibition. The groupings included masculine tropes such as those who wore regimented garb (military men, businessmen, sportsmen) and blue collar wear ("prol" gear), as well as those who lived their lives outdoors (farmers, cowboys, hunters). They were joined by the urbane (man about town and the dandy),

the young (Joe College), and the counterculture rebel.

Collectively, *Jocks and Nerds* enhanced the level of fashion exhibitions while presaging interest in menswear, a trend that would take hold decades later. Patricia Mears

◀ Exhibiting menswear often requires the appropriate accessories to complete an ensemble. Martin's cowboys include the requisite hats, bandanas, chaps, and boots

▼ A procession of menswear "types" conceived by Richard Martin

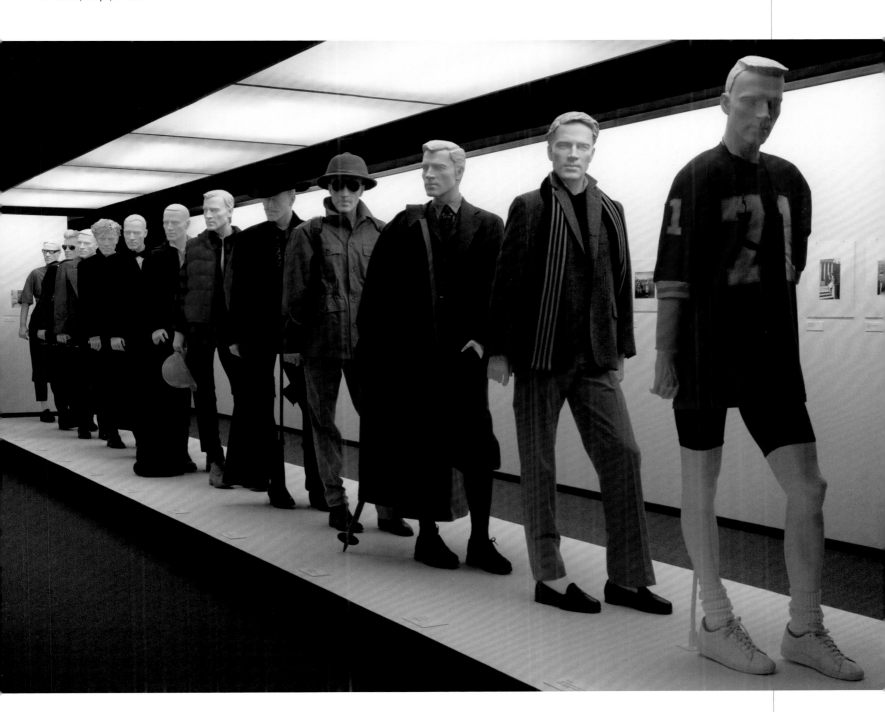

Halston: Absolute Modernism

October 29, 1991 – January 11, 1992
Curators: Richard Martin and Harold Koda

▶ A selection of Halston's streamlined, monochromatic designs

Monographic exhibitions celebrating the work of a single designer always prove to be popular. While commonplace today, such museum presentations were relatively rare until the latter twentieth century, especially for those of living designers, though the same was true for designers who were recently deceased. Organized by Richard Martin, the trailblazing fashion historian and curator, *Halston: Absolute Modernism* debuted less than two years after the designer's death. Martin noted that he was already "planning a modernist show" when the "remarkable austerity and simplicity" of Halston's work led him to mount this retrospective.

While many Halston hallmarks were on view, such as his cashmere and Ultrasuede separates, the most compelling works were garments crafted using the designer's innovative construction methods. To emphasize the skill behind the simplicity, senior curator Fred Dennis, then Martin's assistant, drafted a selection of patterns that were displayed on the walls. Looking like oversized origami artworks, garments crafted from a single pattern piece were cut in shapes ranging from parallelograms to pinwheels with nary an armhole or evident closure. **Patricia Mears**

▼ The complexity and intricacy of Halston's simple-seeming designs were revealed in the recreations of his pattern pieces

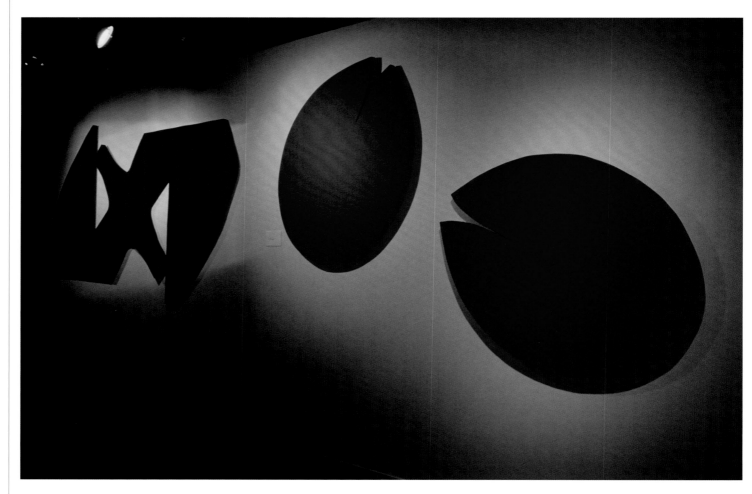

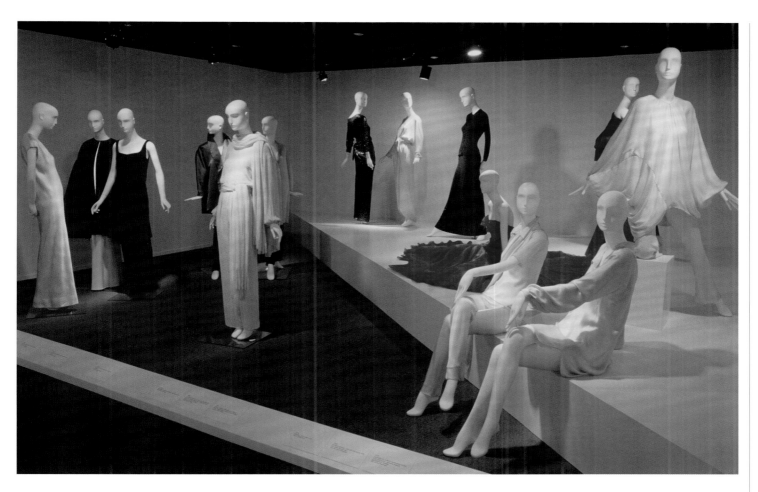

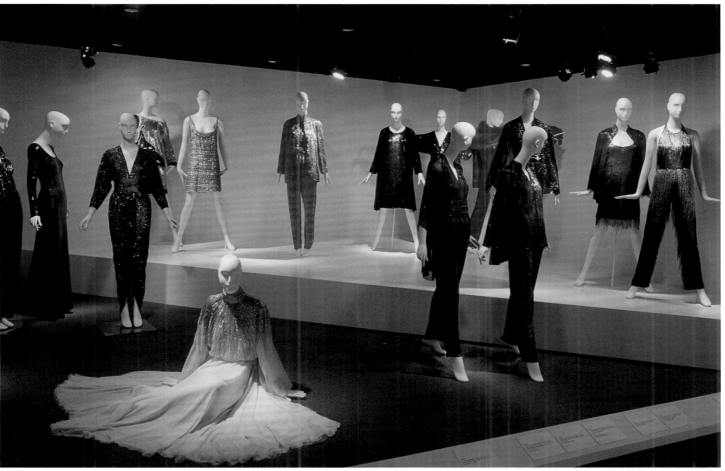

Hello Again: Recycling for the Real World

October 25, 1994 – January 7, 1995
Curators: Zette Emmons and Dorothy Globus

Hello Again was the first major exhibition of items made from recycled and repurposed materials. The 250 objects on view included furniture (loungers "upholstered" with colorful soda cans), household items (a lamp repurposed from a thermos bottle), and sporting goods (a kayak created from recycled plastic milk bottles). Yet it was fashion that took center stage: Moschino crafted couture gowns from plastic bags, Koos van den Akker made a jacket from discarded neckties, and Isaac Mizrahi fashioned a dress from aluminum cans. Several objects donated for the exhibition—including Maison Martin Margiela's sweaters made from old army socks and XULY. Bët's ensembles refashioned from secondhand and bargain-store finds—are early, and important examples of what is now known as "upcycling." The exhibition was staged at a time when designers were beginning to look beyond the altruistic roots of recycling to explore its commercial potential.

The exhibition design, executed by Susan Subtle, featured metal shopping carts, old television sets, and a pile of used tires, in addition to more traditional platforms for display. While the original concept included a bale of crushed aluminum outside the entrance to the museum building, it was removed after an attempt at pilfering by an overenthusiastic scavenger. **Colleen Hill**

▼ Installation view featuring
recycled and repurposed fashions

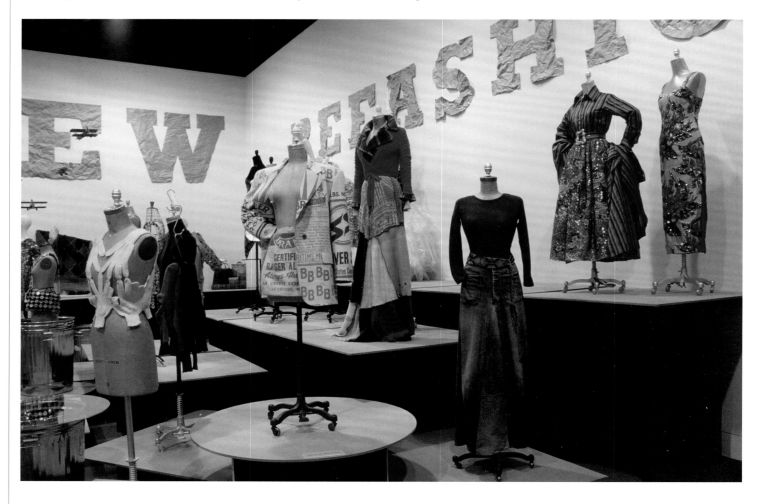

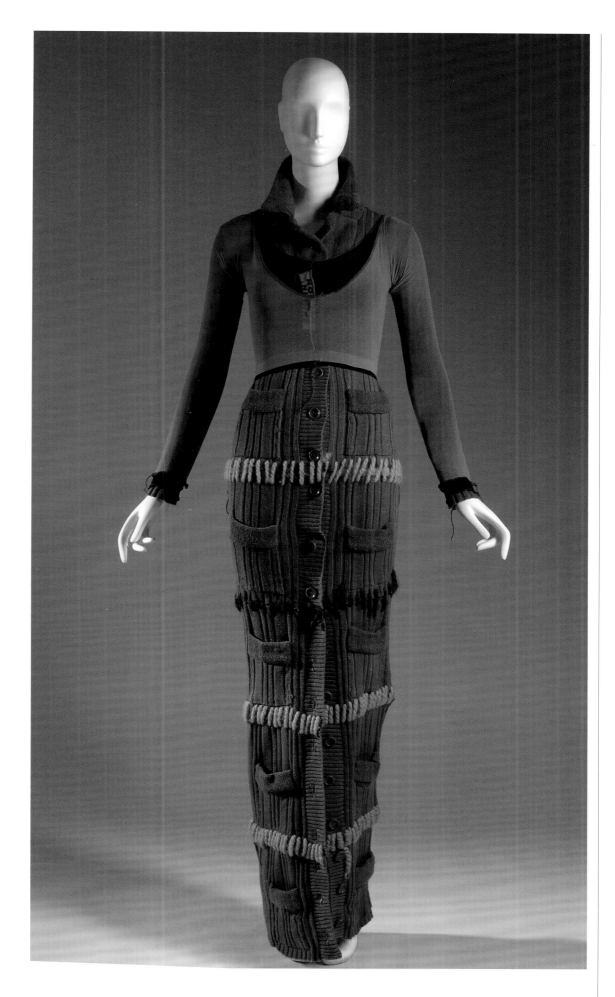

▶ XULY.Bët, ensemble made from repurposed materials, France, fall 1994

China Chic: East Meets West

February 16 – April 24, 1999
Curator: Valerie Steele

China Chic: East Meets West explored the influence of Chinese dress on Western fashion—and also the reverse, the influence of foreign dress on Chinese styles. It is easy to find examples of European and American designers being inspired by Chinese clothing and decorative motifs. Yves Saint Laurent, for example, created extraordinary haute couture garments based on a fantasy image of Cathay, while John Galliano and Christian Lacroix created looks based on the slim-fitting, high-collar, slit-skirt dresses associated with 1930s Shanghai and 1950s Hong Kong. Meanwhile, Donna Karan and Thierry Mugler channeled Maoist workers' uniforms.

What is more difficult—and more important—is to demonstrate that "fashion" is not a purely Western concept. For this reason, the exhibition also featured sculpture from different dynasties to demonstrate how clothing in China changed dramatically over the centuries. Even the *qi pao* (also known by its Cantonese name, *cheongsam*) is not a "traditional" Chinese style. Rather, it is a brilliant example of the cross-cultural fusion of Chinese menswear, Manchu womenswear, and Western flapper dresses—invented in China in the 1920s to convey the idea of a modern Chinese woman. The *cheongsam* was rejected during the Cultural Revolution in the People's Republic of China,

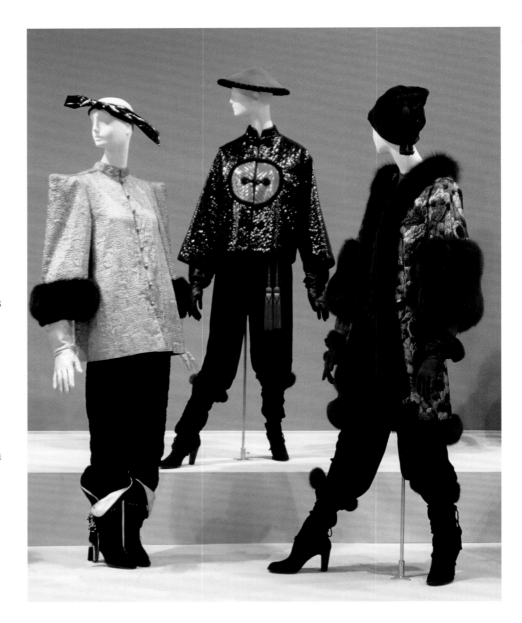

and lost prestige elsewhere in the Chinese diaspora as it became associated with the service industries. However, in recent years, Chinese and Chinese-American designers have reassessed the garment as a sign of cultural identity. Valerie Steele

◀ Chinese-inspired couture
ensembles by Yves Saint Laurent

▼ An installation shot of *China Chic*, featuring fashionable *qi paos*

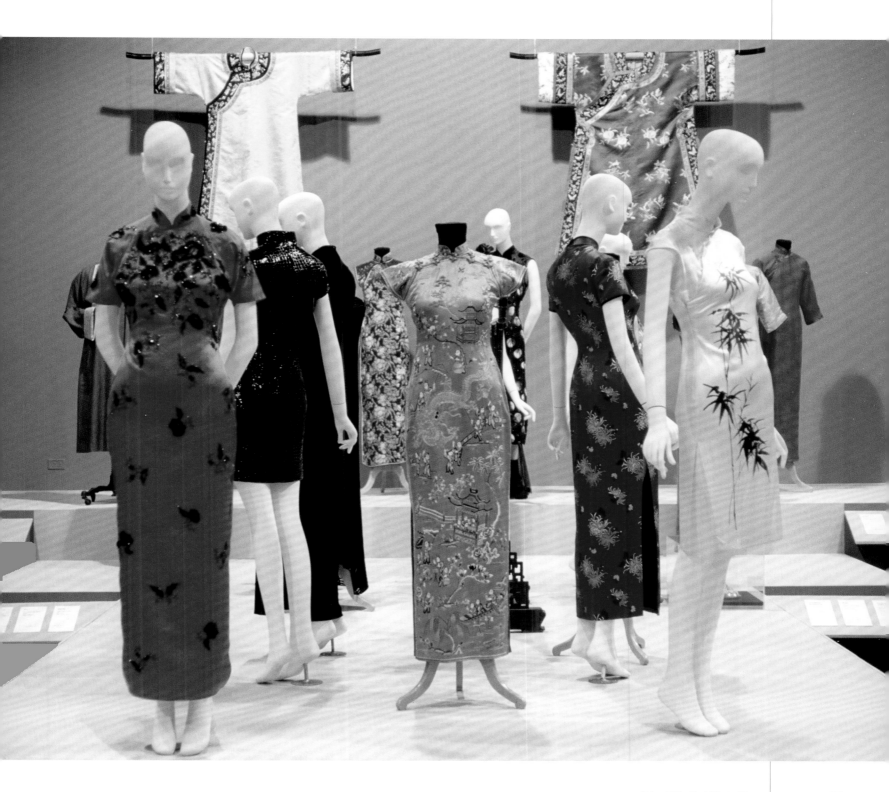

The Corset: Fashioning the Body

January 25 – April 22, 2000
Curator: Valerie Steele

▶ An haute couture evening gown by Christian Lacroix juxtaposed with an 1890 corset

▶ An East African beaded Dinka "corset" inspired Galliano's haute couture evening dress for Dior

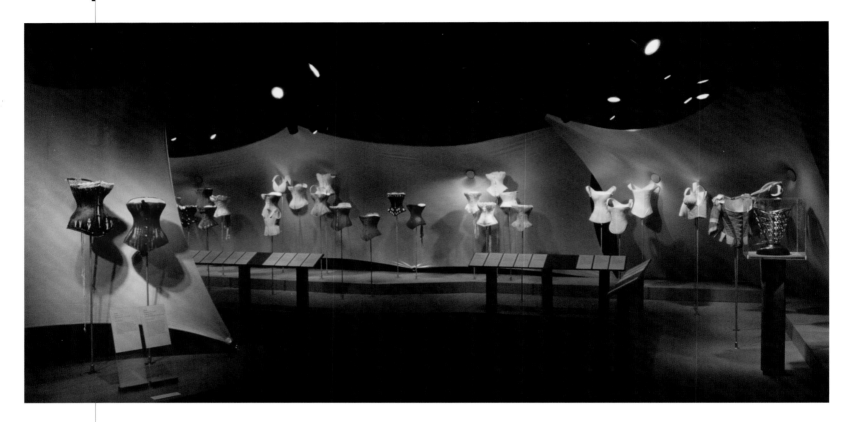

Women throughout the western world wore corsets for 400 years—from the Renaissance into the twentieth century. Yet from the beginning, the corset was controversial, and many people argued that tightly-laced corsets were dangerously unhealthy. Others countered that corsetry was necessary if women were to look attractive and respectable. With the fashion revolution of the early twentieth century, women gradually stopped wearing boned corsets, adopting brassieres and elasticized girdles instead. Corsetry was also internalized through diet, exercise, and plastic surgery.

In the late twentieth century, street styles such as punk brought corsets back into fashion—underwear as outerwear. As an optional item of clothing with a dubious reputation, the corset took on a range of new meanings within the fashion system, where it evoked everything from romantic Victoriana to sadomasochistic fetish-wear and so-called Modern Primitivism.

The Corset was divided into two sections: the first explored the history of the corset, per se, with examples ranging from eighteenth-century stays to a 1950s Merry Widow. There were a number of rare objects, including a man's corset from the late nineteenth century, a cheap mass-produced corset called the "Pretty Housemaid Corset," and what is almost certainly a forgery of a Renaissance iron corset. The second and larger gallery was devoted to showing how the corset had influenced modern and contemporary fashion. Examples ranged from Jacques Fath's 1950s evening gown with corset lacing in back to one of the Jean Paul Gaultier corsets that Madonna wore on her *Blonde Ambition* tour. Valerie Steele

▲ The history of the corset

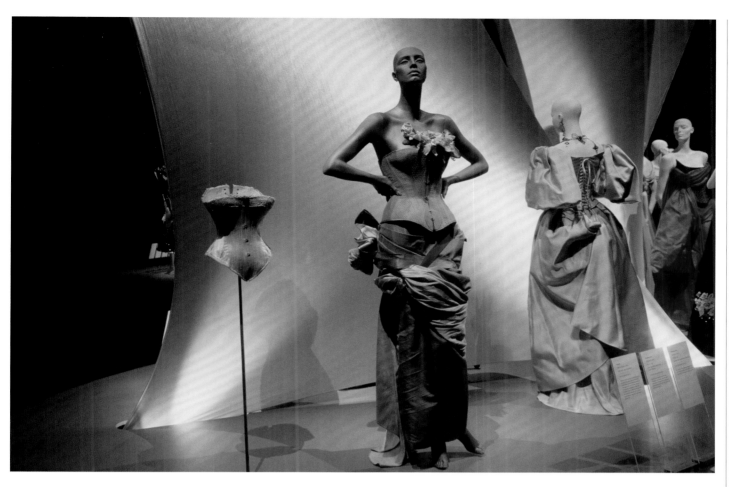

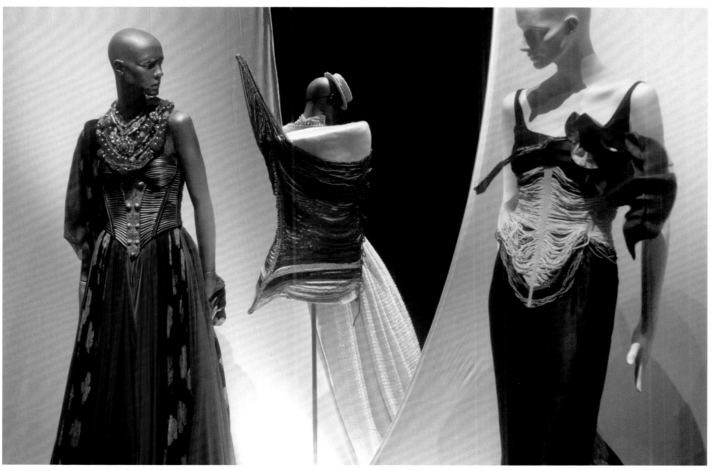

London Fashion

October 17, 2001 – January 12, 2002
Curator: Valerie Steele

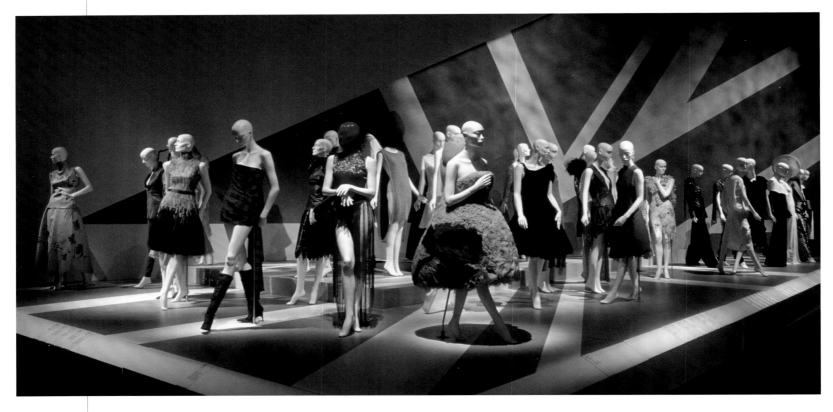

London Fashion received the first Richard Martin Award from the Costume Society of America. This was especially meaningful, because Richard was a good friend and an MFIT colleague, who contributed so much to fashion scholarship. I think he would have liked *London Fashion*, because he always appreciated avant-garde and subcultural styles.

London has been one of the world's most important fashion cities for centuries, but especially since the 1960s, when it was the site of an emerging youth culture, associated with popular music and new styles of dress. Mary Quant's mini-skirts were copied in Paris and New York, while John Stephens' brightly-colored, psychedelic menswear made Carnaby Street the center of the Peacock Revolution. As youth culture evolved, mod fashions gave way to hippie styles, which looked back to earlier bohemian fashions, such as those associated with Liberty of London.

The Punks became the next subcultural-and-music group to put London on the fashion map. Vivienne Westwood was the designer most closely associated with Punk style, dressing the Sex Pistols in bondage wear and T-shirts with obscene images. New subcultural styles, such as the New Romanticism, swept London next, as designers like Westwood and Zandra Rhodes drew on historical dress for inspiration.

The late twentieth century saw the appearance of new stars emerging from London's fashion schools, such as John Galliano, Lee Alexander McQueen, and Hussein Chalayan. McQueen, in particular, loaned MFIT major ensembles from throughout his career, such as the red dress from his "Joan of Arc" collection and the horned jacket from "It's a Jungle Out There." **Valerie Steele**

◄ A "Union Jack" platform featuring clothing by designers such as Alexander McQueen and Hussein Chalayan

▼ A selection of garments by Vivienne Westwood

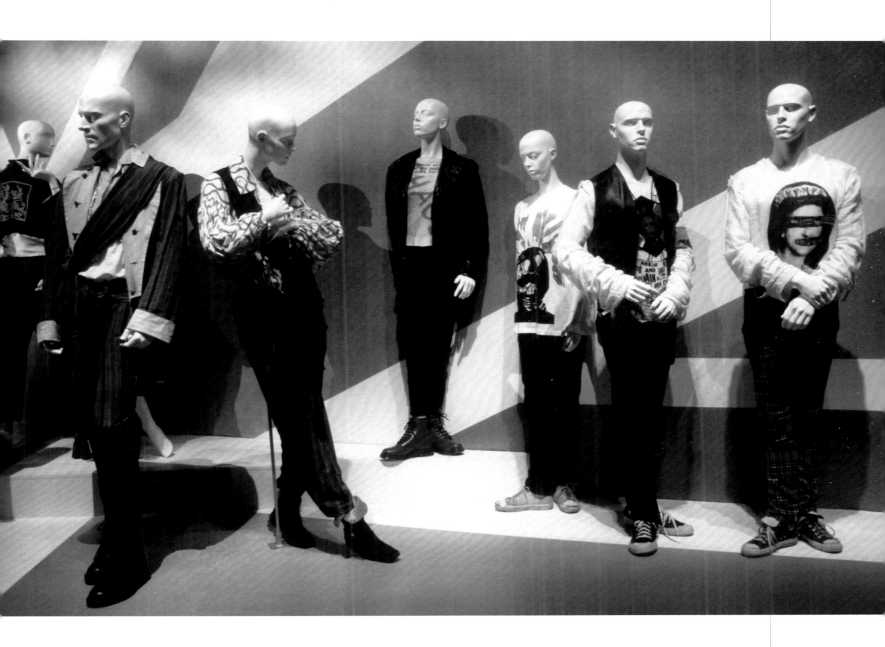

Designing the It Girl: Lucile and Her Style

March 1 – April 16, 2005
Curators: Rebecca Jumper Matheson
and Molly Sorkin (FIT graduate students)

Each year, The Museum at FIT
collaborates with second-year
graduate students in the FIT Masters
program in Fashion and Textile
Studies. Students are assigned roles
akin to those of museum professionals
(curator, conservator, registrar, etc.)
and organize a small, museum-quality
exhibition using objects from The
Museum at FIT and the FIT Library's
Special Collections. *Designing the
It Girl: Lucile and Her Style* was one
example of this ongoing project.
When Lucy, Lady Duff Gordon
(known professionally as Lucile) made
headlines as a survivor of the *Titanic*
in 1912, she was already established as
a couturier. Lucile's aesthetic bridged
the nineteenth and twentieth centuries,
combining modern sensibility with a
heavy dose of romanticism. By 1915,

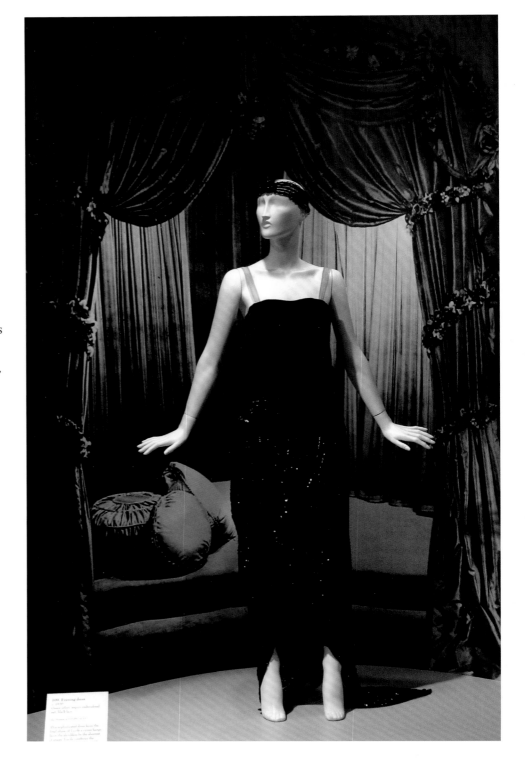

she had couture houses in London, New York, Paris, and Chicago, and prominent "It" girls such as Isadora Duncan and Elsie de Wolfe wore her distinctive creations. This exhibition, which included fashions, photographs, and sketches, was the first to center on the work of this entrepreneurial designer.

While other graduate student exhibitions such as *Lilly Daché: Glamour at the Drop of a Hat* (2007) were likewise focused on the work of one designer, graduate students have also examined variations on a single garment (*Beyond Rebellion: Fashioning the Biker Jacket*, 2014); style icons (*Lauren Bacall: The Look*, 2015); and the evolution of design (*Pockets to Purses: Fashion + Function*, 2018). Colleen Hill

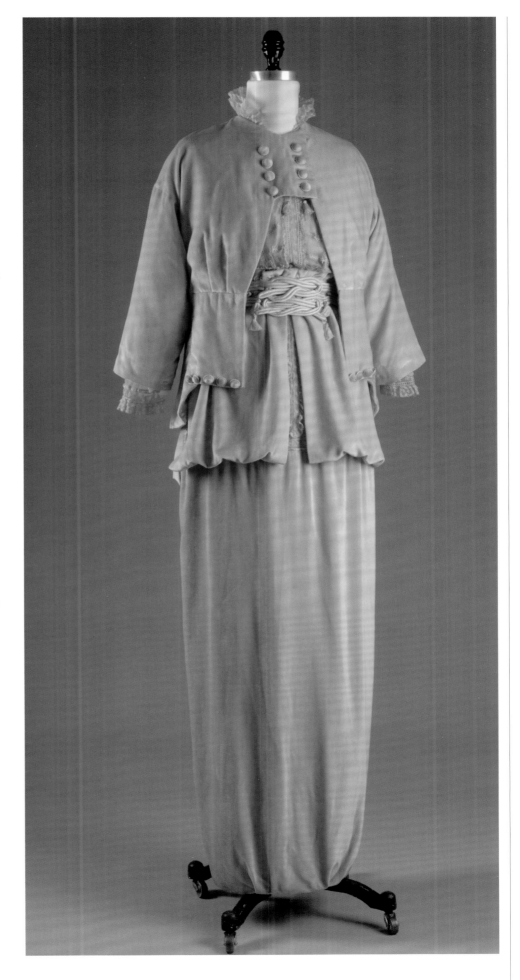

◀ A c. 1922 evening gown by Lucile, shown in front of a photographic reproduction of her salon

▶ Lucile, suit, USA, c. 1913

Madame Grès: Sphinx of Fashion

February 1 – April 19, 2008
Curator: Patricia Mears

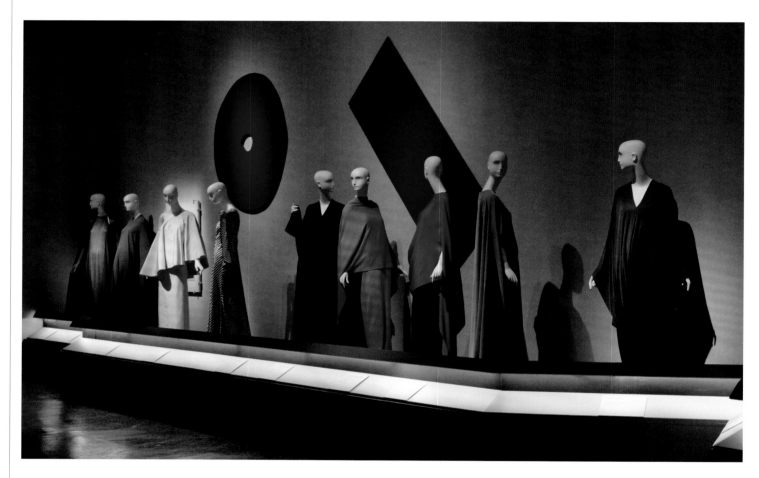

Madame Alix Grès was one of the twentieth century's most brilliant couturiers. During a career that spanned six decades, she handmade garments of exquisite sculptural beauty. She was a prolific creator whose output was consistently documented in leading fashion publications. Perpetually swathed in a turban, she was a mysterious figure who lived up to her nickname, the "Sphinx of Fashion."

Because Grès eschewed novel, thematic collections, her work has often been inaccurately described as unchanging and classic, but in fact she did keep pace with the times and set trends. This MFIT exhibition was the first to document her innovations via Grès's three primary stylistic approaches: her classically-inspired, "Grecian" pleated gowns that she refined throughout her entire working life; the sculpted billowing, three-dimensional coats and gowns that she perfected during the midcentury; and her highly innovative and influential geometrically constructed "ethnic" caftans and pajamas dating to the 1960s and 1970s.

Madame Grès elevated dressmaking to an art form as she worked in solitude, perfecting her self-taught methods of construction. She was the last of the Golden Age couturiers. Her work was given its due with funding from The Coby Foundation, Grès Paris, and Yagi Tsusho, Limited. The companion book received the first prize in the American Alliance of Museums publication design competition. **Patricia Mears**

◄ The simple pattern pieces of these flowing caftans and evening sets are deceptively difficult to execute

▼ Sculptural daywear, eveningwear, and coats show the range of Grès's work

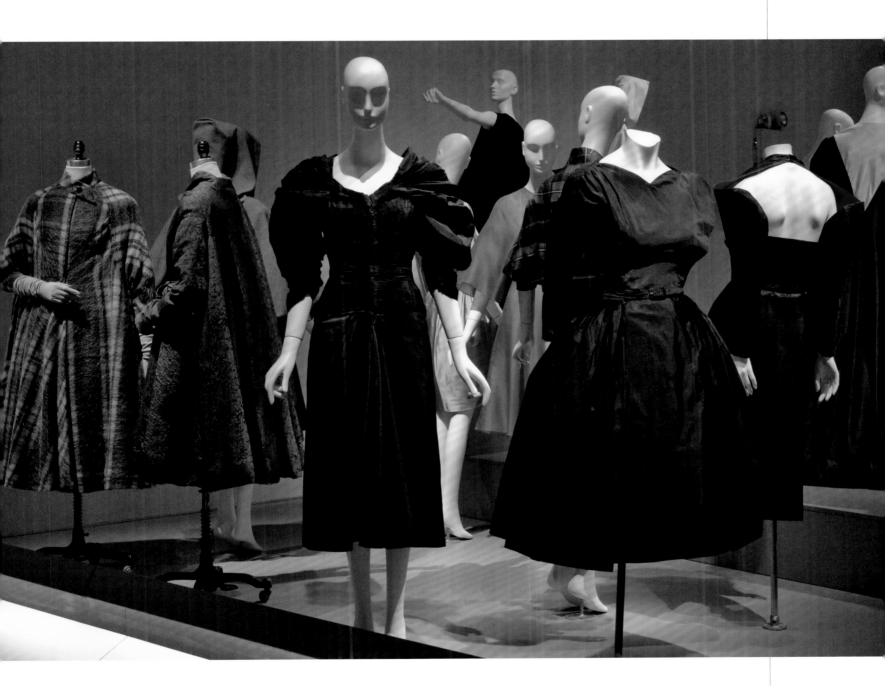

▼ A selection of "Grecian" pleated gowns

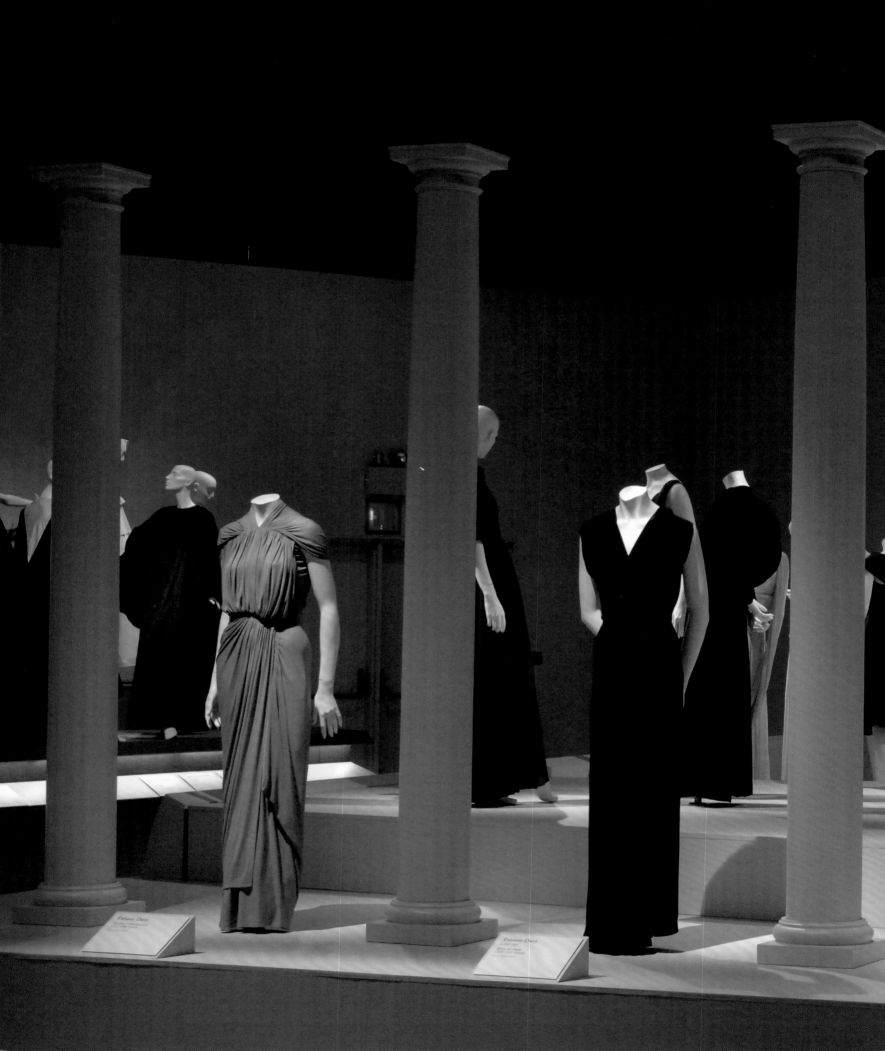

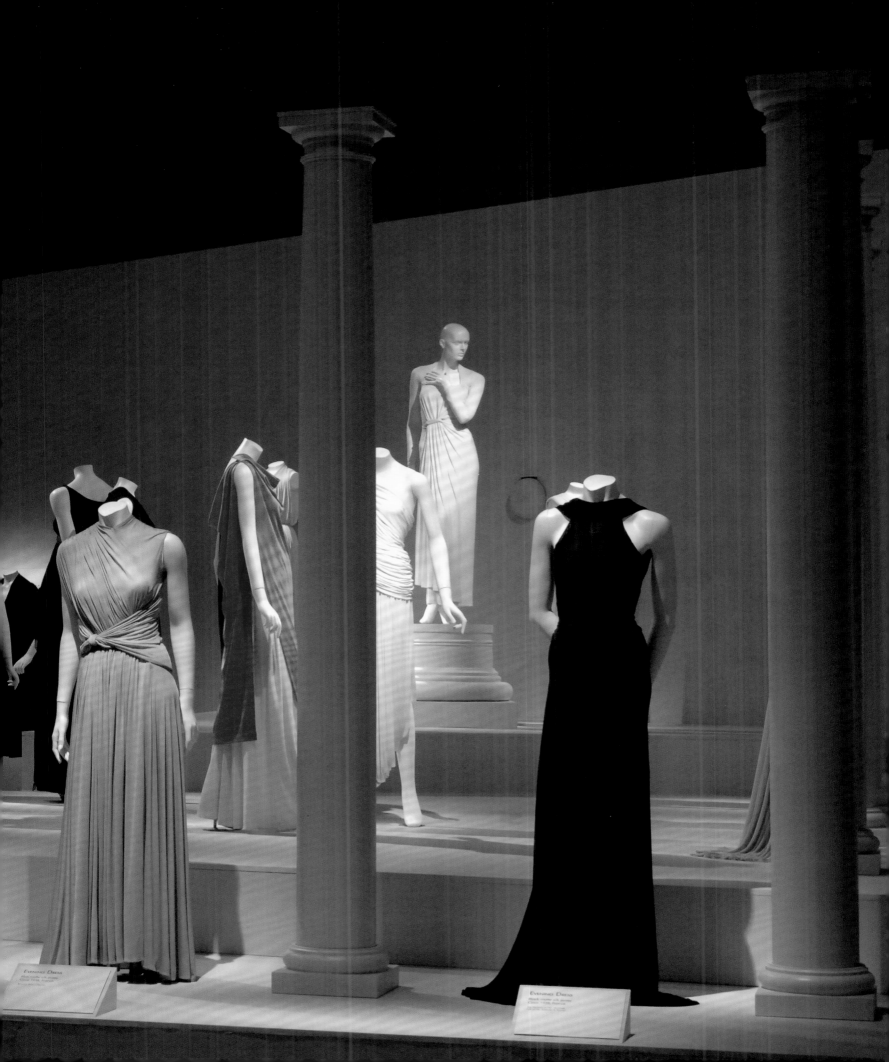

Gothic: Dark Glamour

September 5, 2008 – February 21, 2009
Curator: Valerie Steele

In 1994, Chanel developed a very dark, red-black nail polish called Vamp. The same year, the Victoria & Albert Museum launched the exhibition, *Streetstyle: From Sidewalk to Catwalk*, a pioneering show that explored the relationship between subcultural styles, such as punk, and high fashion. These two events inspired me to create a lecture on gothic themes in fashion, which I presented to graduate students in FIT's Museum Studies program. Flash forward a decade, and I am working at The Museum at FIT, where I decide to organize the exhibition, *Gothic: Dark Glamour*. Much as I had admired the V&A's *Streetstyle* exhibition, my research led me to conclude that fashion designers such as Alexander McQueen, Rick Owens, and Olivier Theyskens were not appropriating goth street style. Rather, designers and goths were drawing on the same visual vocabulary that had also inspired a range of cultural forms from vampire films to the art and literature of the erotic macabre.

Simon Costin, who had collaborated with McQueen, helped us create a dramatic *mise-en-scène* featuring suitably gothic settings, such as a ruined castle and a haunted palace—architectural metaphors for a disturbed mind. Simon also created a laboratory with rubber walls, where fashion "monsters" were created. We were able to borrow and sometimes acquire extraordinary dresses. **Valerie Steele**

▼ The "laboratory" featured a McQueen corset and sinister looks by Kei Kagami

▼ An ensemble by John Galliano for Christian Dior haute couture, spring/summer 2006

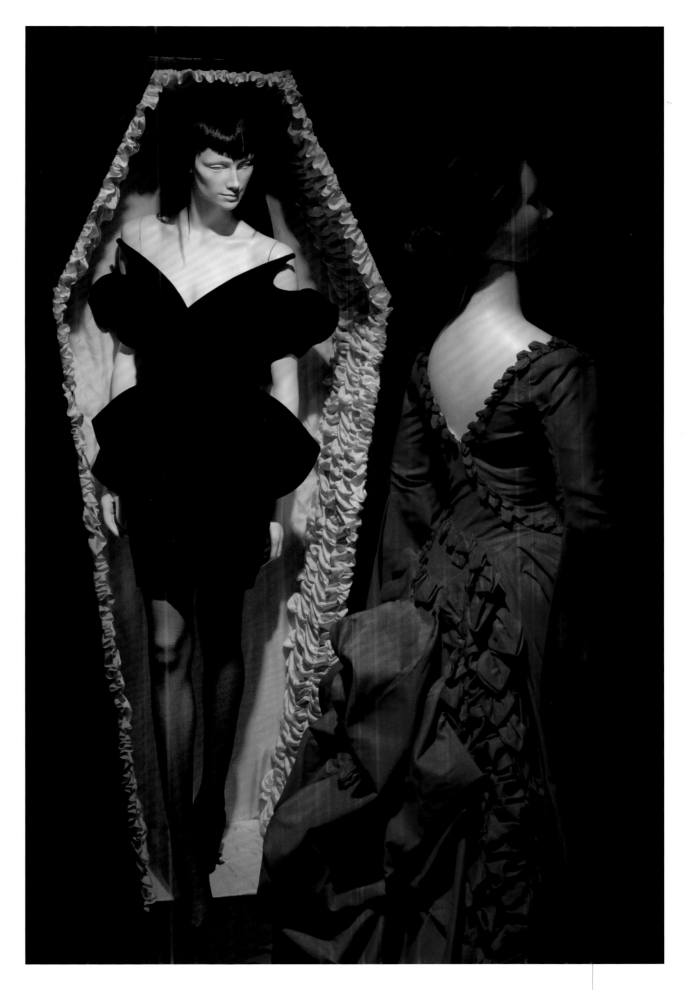

▶ A "vampire" dress by Thierry Mugler and a costume by Eiko Ishioka for the 1992 film *Bram Stoker's Dracula*

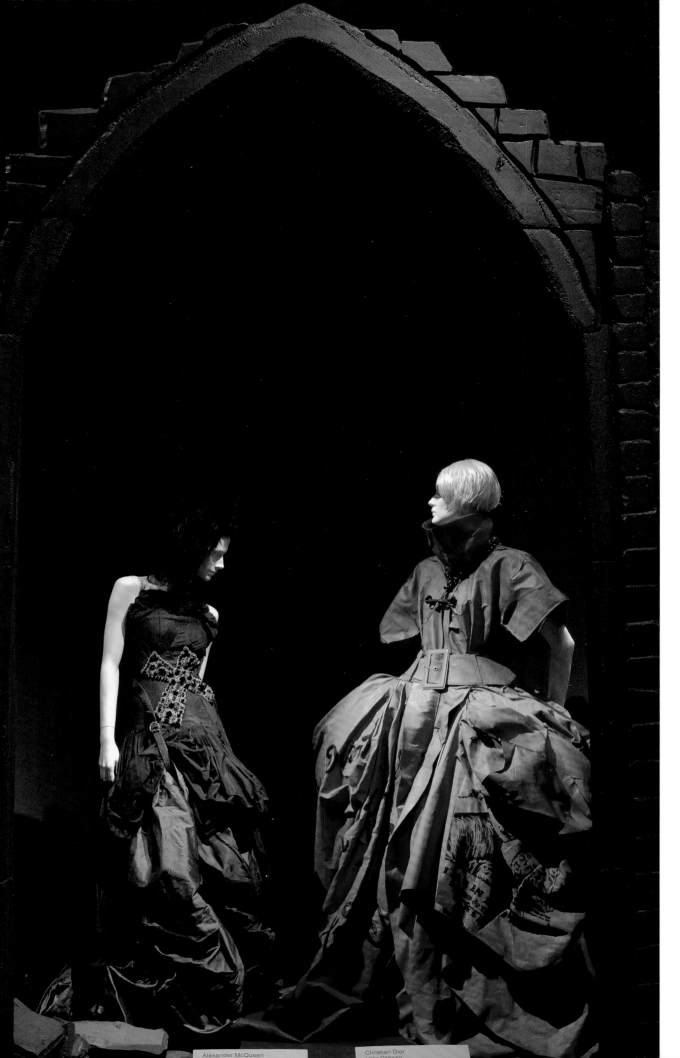

◄ The ruined castle framed dresses by Alexander McQueen and by John Galliano for Christian Dior haute couture

► A gown from Alexander McQueen's *Voss* collection, spring/summer 2001

Alexander McQueen

Christian Dior
(John Galliano)

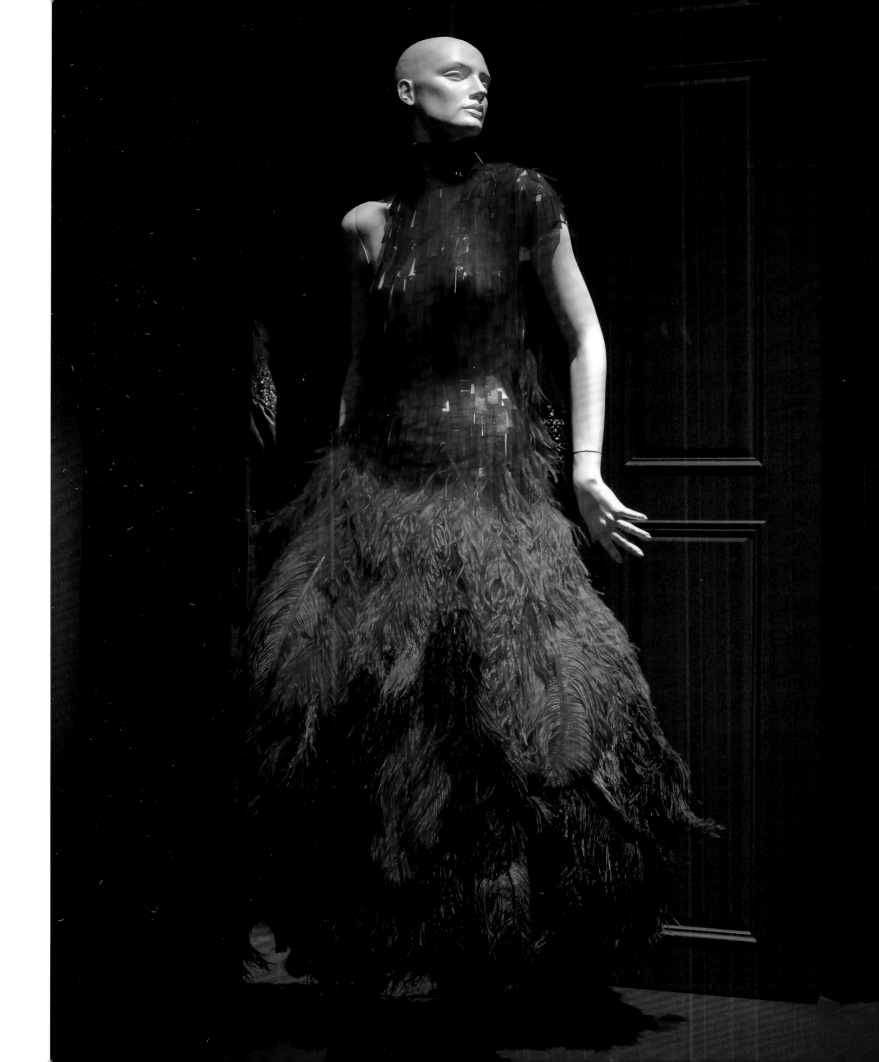

American Beauty: Aesthetics and Innovation in Fashion

November 6, 2009 – April 10, 2010
Curator: Patricia Mears

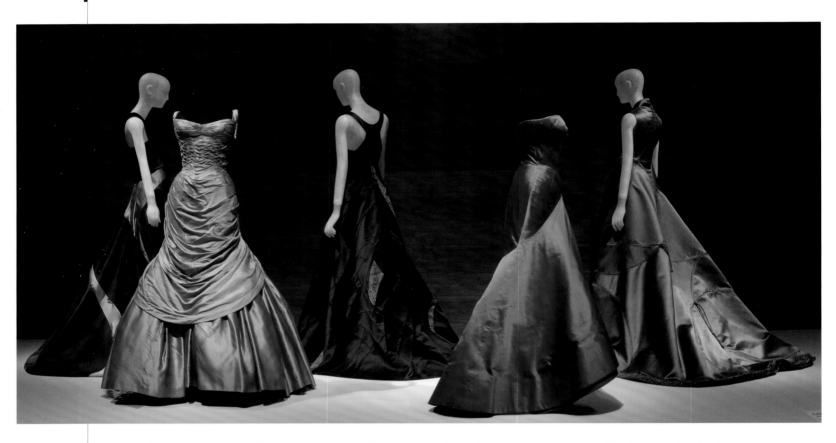

America's most innovative designers created groundbreaking clothing that was not limited, as is often assumed, to the production of casual and functional clothing such as denim jeans and sportswear. Covering work from the 1930s to the present, this exhibition presented how technical aspects of modern dressmaking influenced aesthetics, or the "philosophy of beauty."

A diverse range of designers who specialized in everything from activewear to evening gowns was represented by clothing types from highly innovative yet affordable ready-to-wear to luxurious and exacting couture. To illustrate the connections between generations of designers and their evolutions, objects were arranged according to their specific methods of construction, such as the use of geometric forms, dressmaking, tailoring, highly structured or "engineered" eveningwear, and embroidery and other surface embellishment.

Many of the two dozen designers featured in the exhibition were not famous, or had been all but forgotten. Yet all were chosen for the beauty of their work, for the fact that most of their clothing was produced in the United States, and because each designer utilized clothing construction as the departure point in his or her design process. **Patricia Mears**

◀ Designers such as Charles James, whose gowns are pictured in the foreground, employed rigid understructures to achieve sculptural forms

▼ Striped and checked fabrics are meticulously crafted into bold, mitered designs

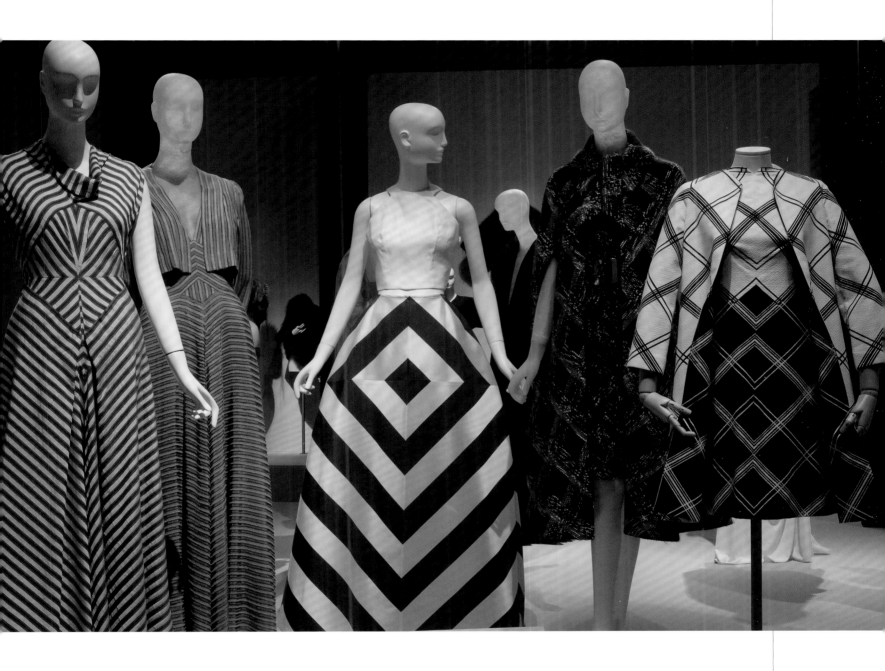

▼ *American Beauty* exhibition overview

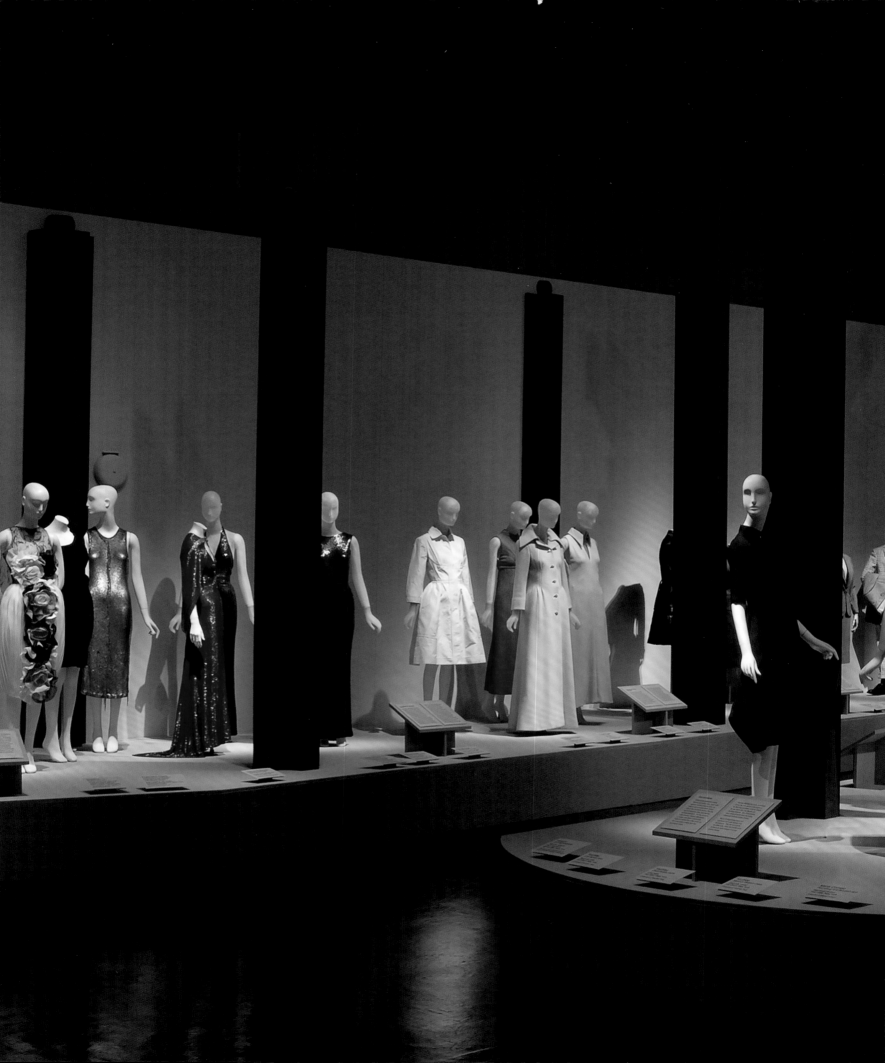

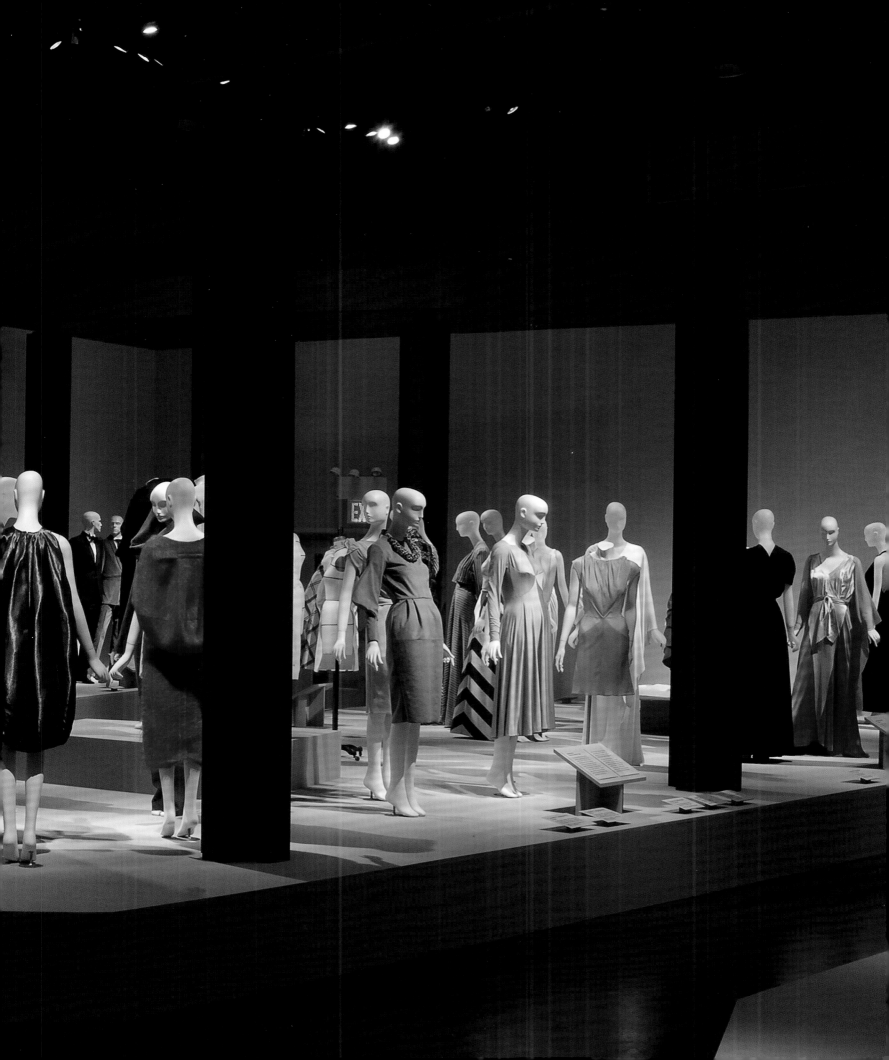

Eco-Fashion: Going Green

May 26 – November 13, 2010
Curators: Colleen Hill and Jennifer Farley

Was concern over fashion's impact on the environment merely a phase? Although sustainability has become integral to today's fashion industry, its long-term viability was unknown when *Eco-Fashion: Going Green* was organized. Rather than include only contemporary clothing, the curators chose to examine fashion's relationship with people and the environment both past and present, featuring garments from the mid-eighteenth century to the twenty-first century. Presented chronologically, contemporary methods of "going green" were used as a framework for studying the past. The objects were selected to represent one or more of six major themes: repurposing and recycling; material origins; textile production; quality of craftsmanship; labor practices; and treatment of animals.

One of the largest industries on the planet, fashion is also one of the most harmful. While the exhibition highlighted problems such as pollution, diminishing natural resources, and inhumane labor conditions, it also emphasized positive practices, such as fiber recycling and the "slow fashion" movement. *Eco-Fashion: Going Green* reminded visitors that an examination of the past can help us shape a better future. In 2011, the exhibition won the Richard Martin Award from the Costume Society of America.

Colleen Hill

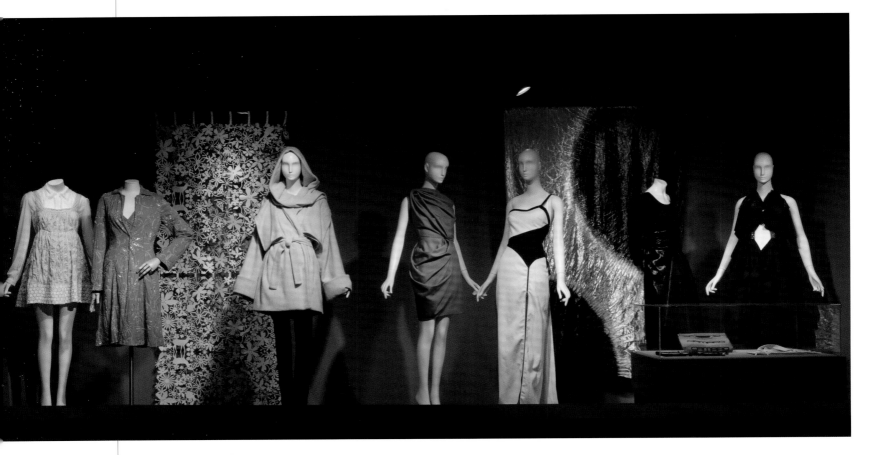

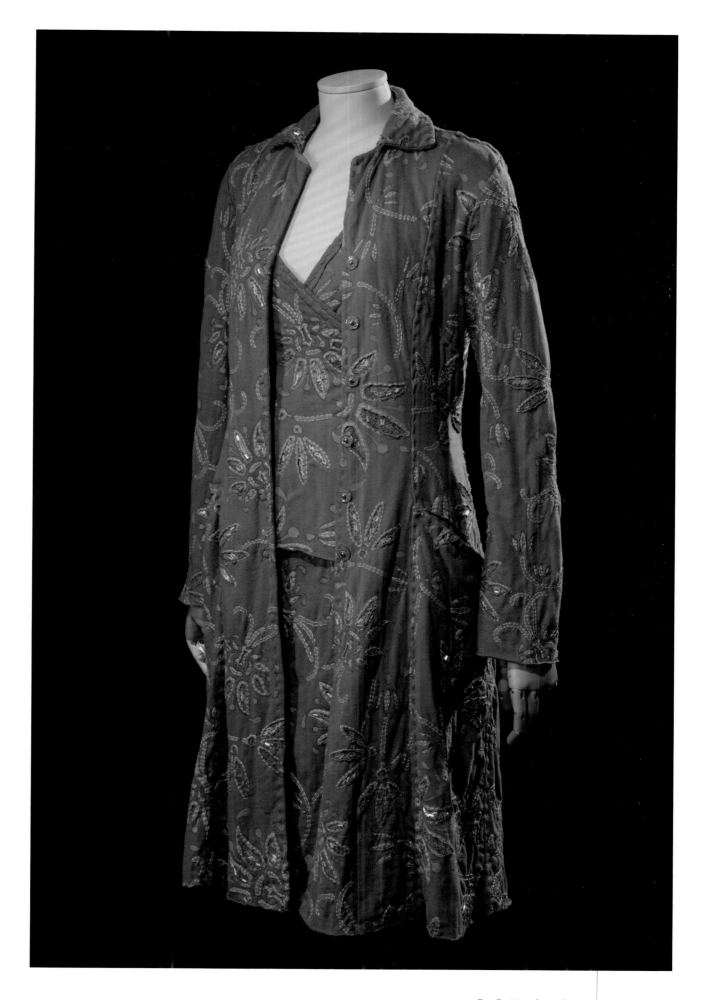

◄ The introductory platform featuring contemporary eco-fashion designs

▶ Alabama Chanin, ensemble, USA, spring 2010

Japan Fashion Now

September 17, 2010 – January 8, 2011
Curator: Valerie Steele

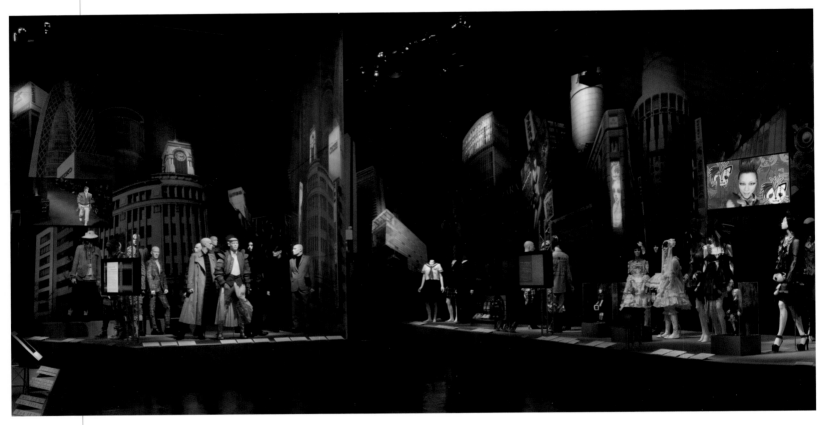

There have been a number of exhibitions devoted to the Japanese "fashion revolution" of the 1980s. *Japan Fashion Now* opened with a gallery devoted to the three pioneers of modern Japanese fashion—Issey Miyake, Yohji Yamamoto, and Rei Kawakubo of Comme des Garçons. But it went on to explore the diversity of Japanese fashion in subsequent decades, embracing established and emerging designers, menswear, street style, and even cosplay.

The main gallery featured dramatic wall graphics evoking the cityscape of twenty-first-century Tokyo, one of the world's great fashion cities. Approximately ninety ensembles were organized on four platforms representing different themes and neighborhoods. Avant-garde fashion occupied the left platform, loosely associated with Omotosando, with looks by Rei Kawakubo and Junya Watanabe of Comme des Garçons, Jun Takahashi of Undercover, Sacai and Matohu. Menswear, one of the most exciting categories in contemporary fashion, was showcased at the far end of the gallery. Street and subcultural styles dominated the long platform on the right, which evoked youth-oriented neighborhoods such as Harijuku and Shibuya. Styles ranged from the elegant and bizarre Kamikaze suits worn by members of Japan's notorious Speed Tribes in the 1990s to the latest Forest Girl styles. The significance of *kawaii* (cute) culture in Japan was exemplified by the Princess Decoration style, classic Lolita looks and Gothic-Punk Lolitas. A fourth platform was devoted to Costume Play, a type of fan culture associated with *anime*, *manga*, and the neighborhood of Akihabara.

Valerie Steele

◀ Large-scale graphics evoked
the Tokyo cityscape

▼ Gothic and Lolita styles
representing the neighborhoods
of Harijuku and Shibuya

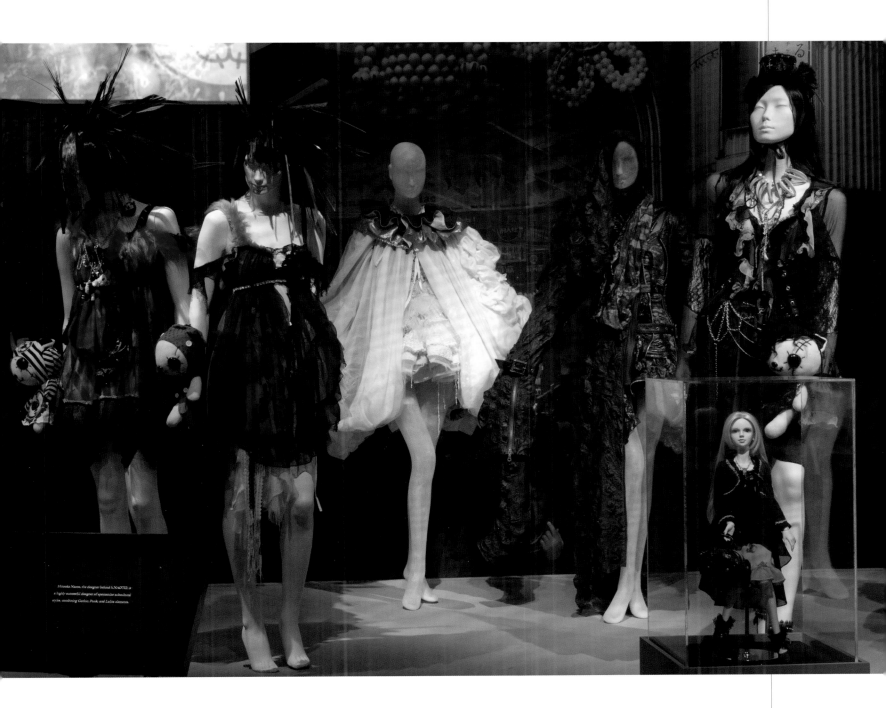

Daphne Guinness

September 16, 2011 – January 7, 2012
Curators: Valerie Steele and Daphne Guinness

There have been many museum
exhibitions about great fashion
designers, but surprisingly few about
the women who made the designers'
clothes come alive. Daphne Guinness
has been an inspiration to many
designers, especially the late
Lee Alexander McQueen. More than
a muse, she is a true fashion icon.
It is not just that she is fearless about
wearing extreme clothes and shoes.
She also has the imagination
and individuality to make every look
her own.
The very first time I met her, I asked
Daphne if she would do an exhibition
with me. At first she was reluctant,
but I convinced her that the students
at FIT would love to see her collection
and share her passion. To my
amazement and delight, she had
documented her entire collection on a
computer data base, making it easy to
research. We spent two years working
on the exhibition and the book,
ultimately choosing about 100 looks.

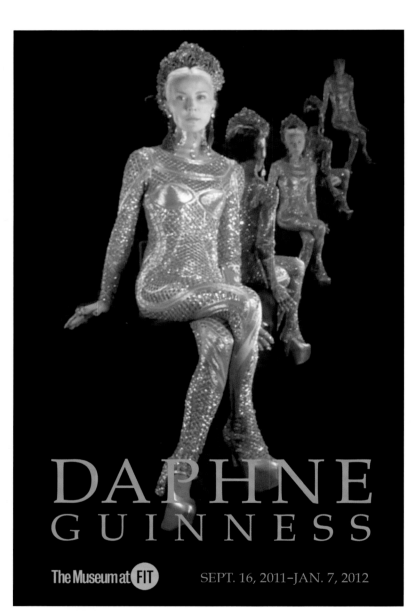

▲ The cover of the brochure
showed our "hologram"
of Daphne. She spoke at the
symposium and signed a
hundred books and brochures

Daphne and I were co-curators. Together we chose every look on display, and I suggested that we organize the looks, not by designer, but rather according to the different aspects of Daphne's personal style. For example, there was an important section on dandyism and another on armor, a third on exoticism, and a fourth simply on garments that sparkled. Daphne styled every ensemble herself. I only interceded to insist that she not use real diamonds. We created a moving "hologram" of Daphne, wearing a silver McQueen cat suit and putting on her diamond jewelry. Of course, we did not shoot two lasers at Daphne, as we would have needed to do in order to make a real hologram. Instead, we used two cameras to create what is known as Pepper's ghost—a simulacrum of Daphne floating above the exhibition.
Valerie Steele

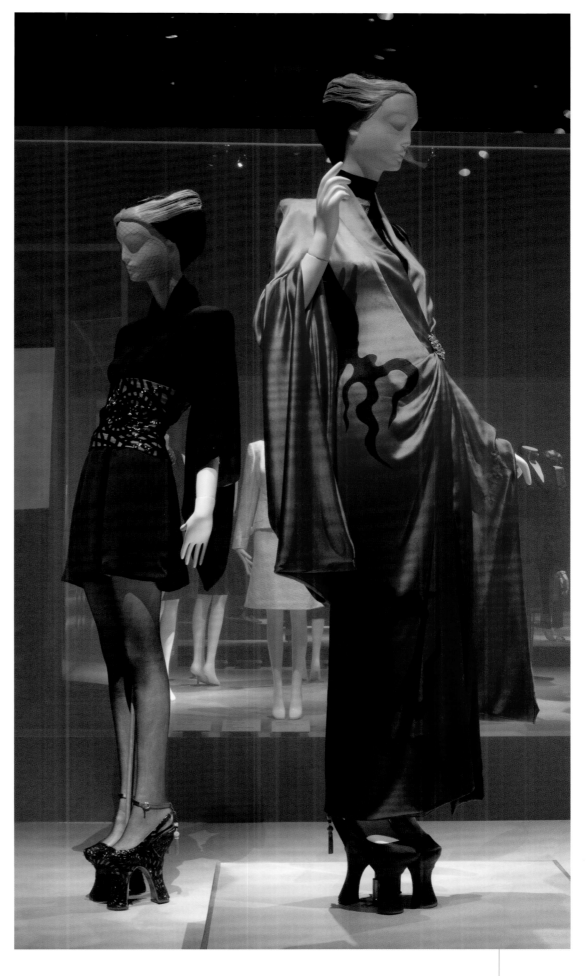

▶ Installation shot of Daphne's exhibition

Ivy Style

September 14, 2012 – January 5, 2013
Curator: Patricia Mears

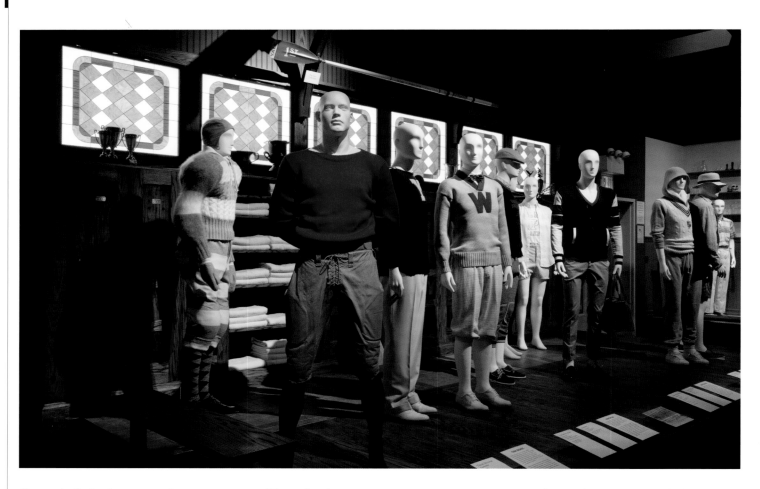

"Ivy style," also known as the "Ivy League look," is one of the most enduring and recognizable sartorial modes in the world. This exhibition illustrated how a small repertoire of classic items—tweed jackets, button-down shirts, khaki pants, and "weejuns" loafers—moved from elite, all-male universities to the realm of international fashion. It was also a pioneering exhibition that spearheaded the recent surge of menswear retrospectives.

Viewed today as a conservative, even static, way of dressing, Ivy style was originally a cutting-edge look. Prior to World War II, elements from the English gentleman's wardrobe were appropriated and then re-contextualized by students at schools such as Harvard, Yale, and especially Princeton. After World War II, Ivy style began to incorporate elements from a new and large demographic, working class GIs, as it spread beyond the campus to a diverse

population that notably included jazz musicians.

Ivy style fell out of favor by the late 1960s, but regained popularity during the 1980s. Purists may bemoan that Ivy, now known as "preppy" style, has been appropriated by fashion. Yet this classic look has endured and thrived for decades because it can be tweaked and even upended without losing its classic, spirited essence. **Patricia Mears**

◄ Components of college
sports uniforms were incorporated
into everyday menswear

▼ Ivy style is characterized
by relaxed cuts and bright
colors and patterns

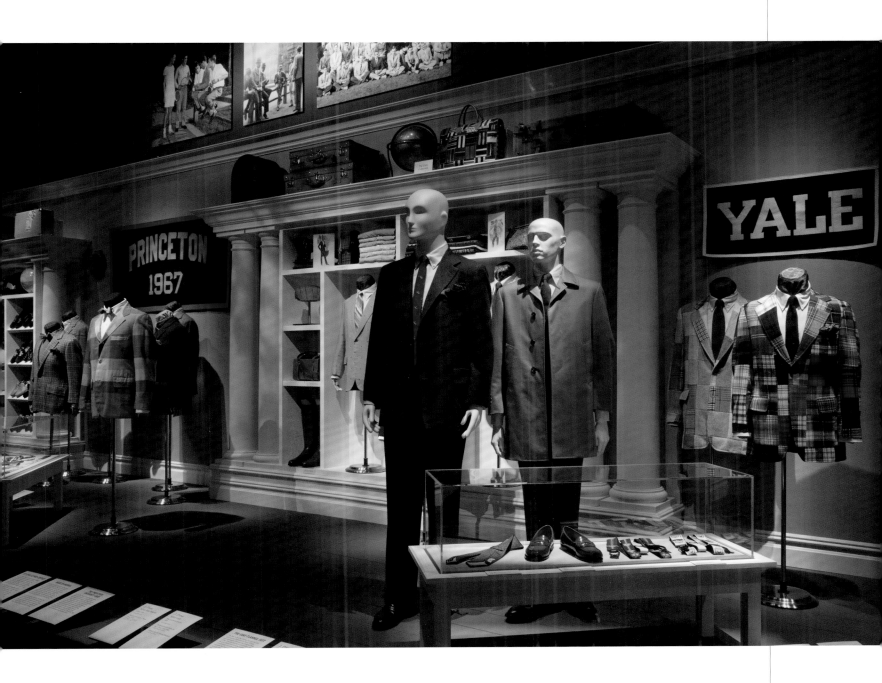

▼ The exhibition design
recreated collegiate spaces,
including the grassy "quad"

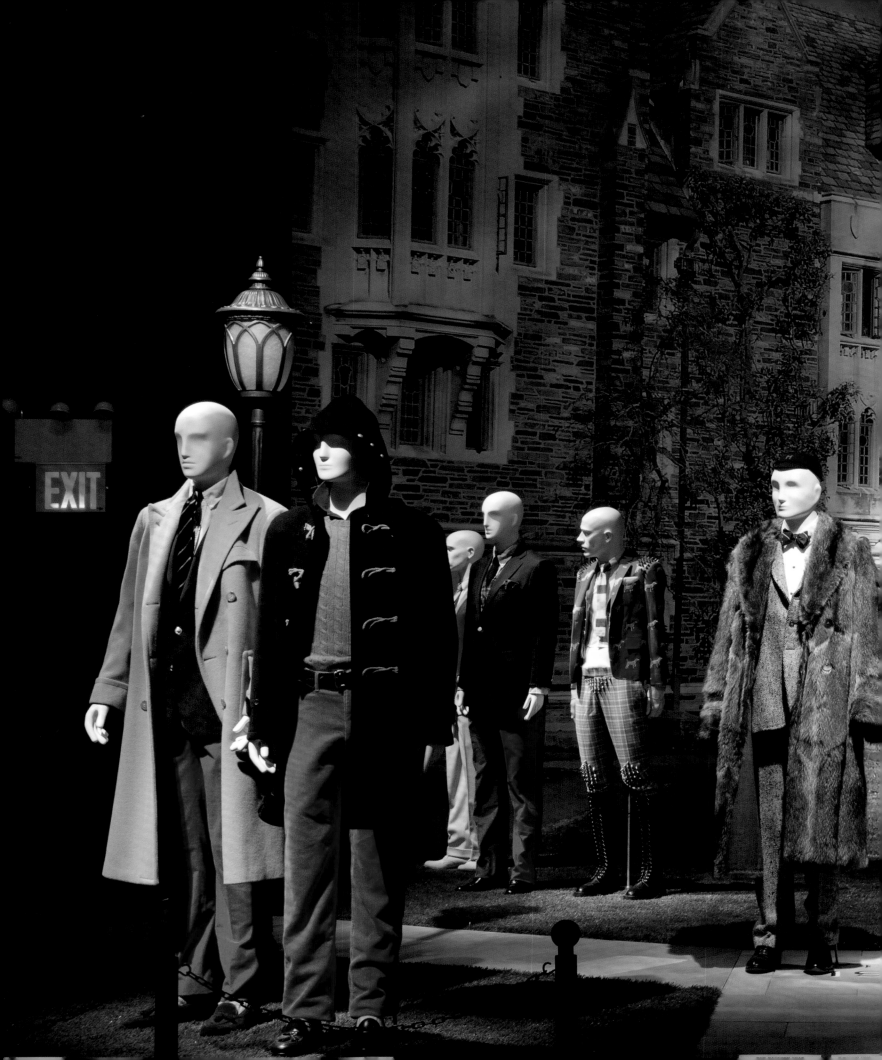

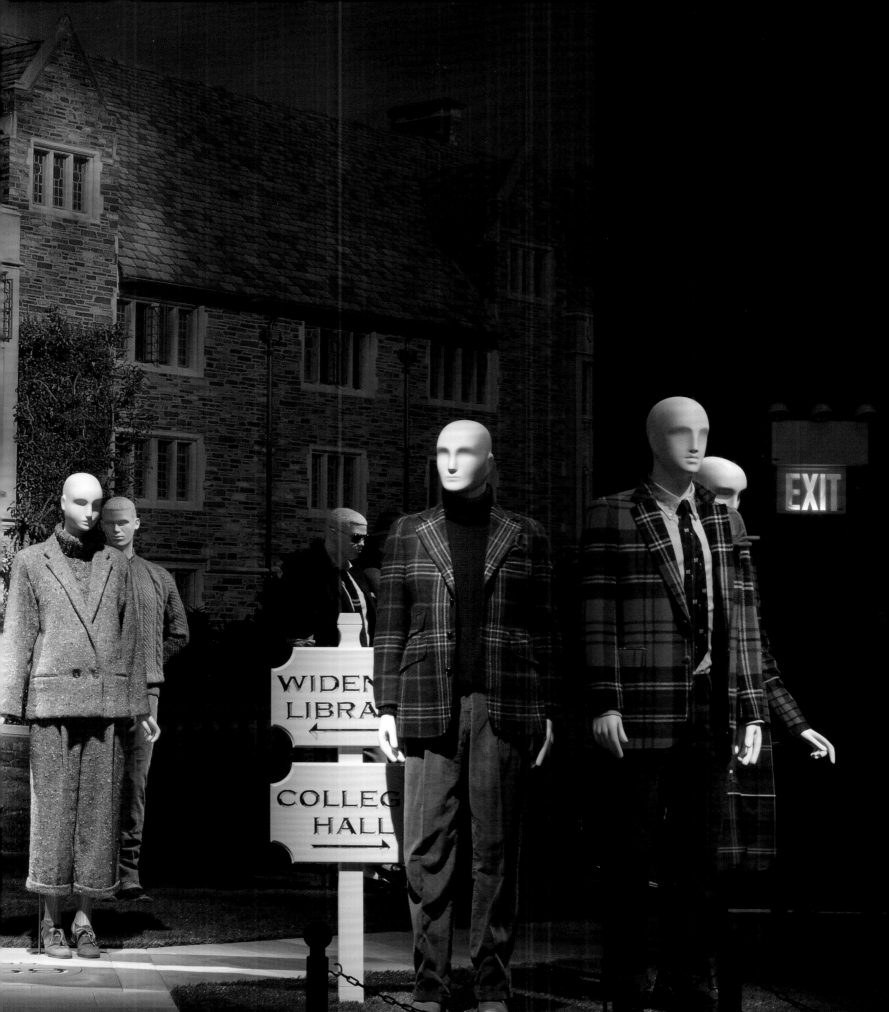

Shoe Obsession

February 8 – April 13, 2013
Curators: Valerie Steele and Colleen Hill

In 1999, Valerie Steele curated the exhibition *Shoes: A Lexicon of Style*, a study of "the obsession, the fetish, and the fashion of shoes." That obsession would only grow stronger: during the early years of the twenty-first century, shoes eclipsed "It" bags to become the most important fashion accessory. Designer footwear styles rose not only in status and cost, but also in height: the most fashionable shoes were so tall that even a 4-inch heel was considered low.

The 2013 exhibition *Shoe Obsession* examined our ever-growing fascination with extreme and extravagant footwear, featuring more than 150 examples of contemporary design. Styles from established labels such as Manolo Blahnik, Christian Louboutin, and Roger Vivier were shown alongside work by up-and-coming stars, including Nicholas Kirkwood and Alessandra Lanvin of Aperlaï. Experimental work—exemplified by Maison Martin Margiela's glass slipper and Noritaka Tatehana's 18-inch "pointe" shoes—emphasized imagination over pragmatism. Inspired by the idea that shoes are sometimes likened to sculpture, individual shoes were placed on pedestals within large plexiglass towers, allowing visitors to view the designs from every angle. Several towers were devoted to shoes worn by individual women, such as style icon Daphne Guinness and jewelry designer Lynn Ban, whose collections of designer footwear numbered more than 200 pairs. The exhibition received a record number of visitors, and sparked many conversations about the role of function in fashion. **Colleen Hill**

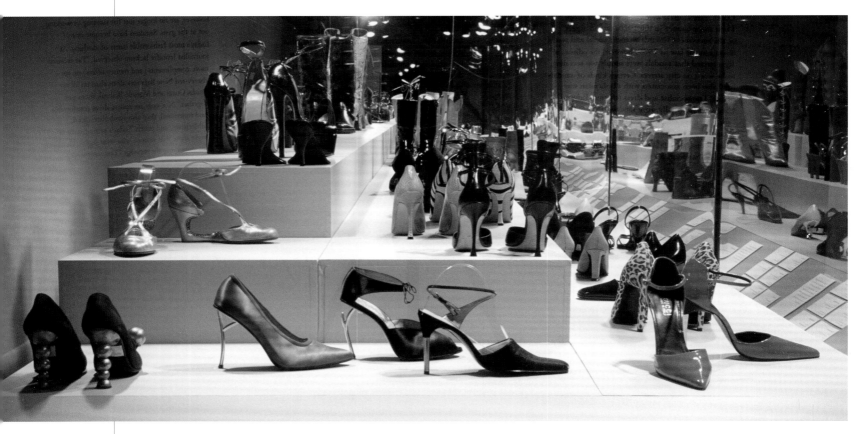

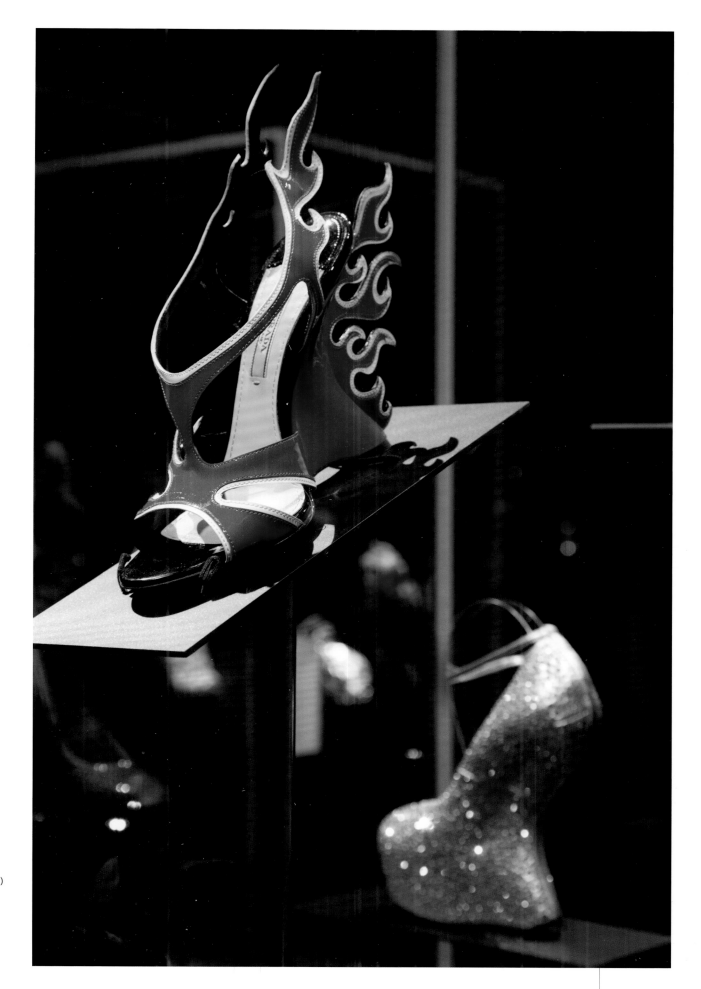

◄ Historic and contemporary high-heeled shoes on view in *Shoes: A Lexicon of Style* (1999)

► A Prada shoe from the collection of Lynn Ban

▼ The main gallery of *Shoe Obsession*, featuring more than 100 shoes

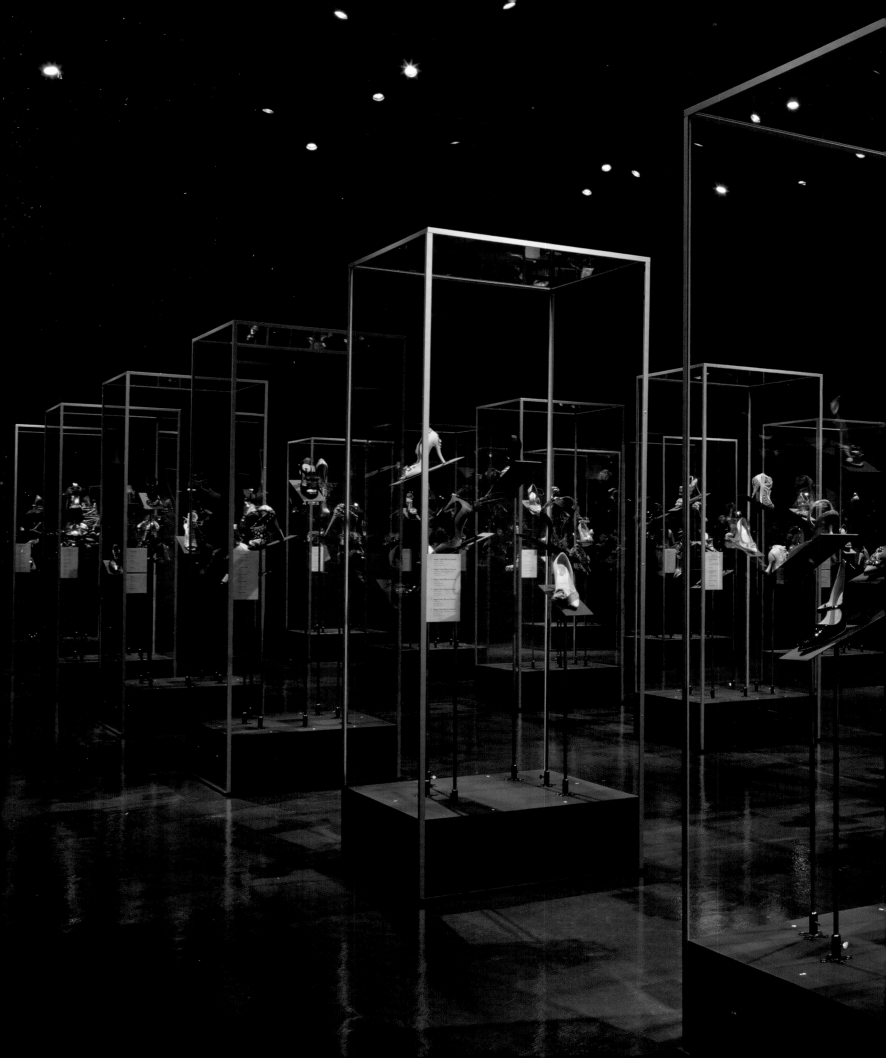

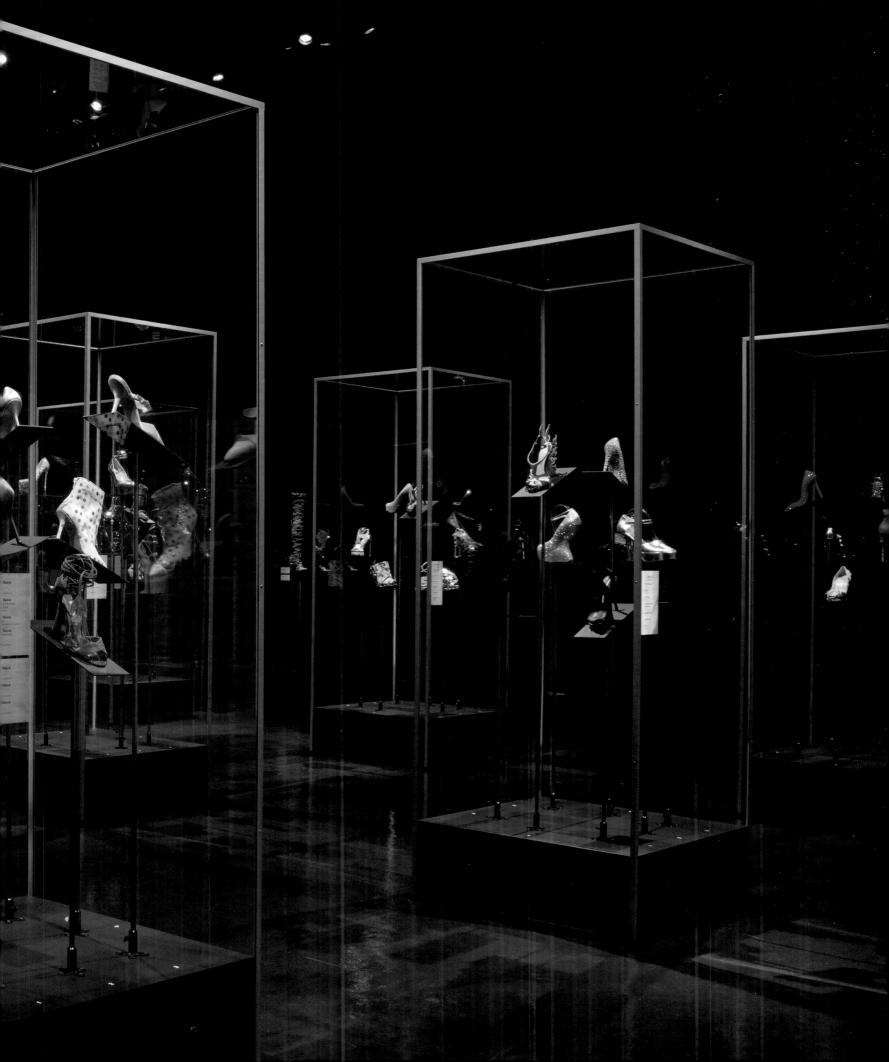

A Queer History of Fashion:
From the Closet to the Catwalk

September 13, 2013 – January 4, 2014
Curators: Valerie Steele and Fred Dennis

A Queer History of Fashion: From the Closet to the Catwalk was the first museum exhibition to explore 300 years of fashion history through a queer lens. Arranged chronologically to show change over time, it was based on recent scholarship and benefitted from a diverse advisory board, many of whom also contributed to the book and the symposium.

From Christian Dior to Yves Saint Laurent and Alexander McQueen, the importance of gay designers to modern fashion is undeniable, yet seldom mentioned. Fashion has also played an important role within the LGBTQ community, as people developed styles that enabled them to recognize each other in an often hostile environment. Many of these styles would later influence mainstream fashion.

"Oh, yes, my sexuality has been very important to my creativity," recalled Yves Saint Laurent, whose influential *Le Smoking* was inspired by Marlene Dietrich's cross-dressing. We were lucky enough to borrow several of Dietrich's menswear ensembles from Deutsche Kinemathek in Berlin. Another important loan was Gianni Versace's black leather bondage evening gown.

The exhibition, designed by architect Joel Saunders, was supported by The Coby Foundation, MAC Cosmetics, and the Couture Council. It received the 2013 Award of Merit from the Museum Association of New York. The website received the 2014 Silver Muse Award from the American Alliance of Museums, and the book received the 2014 Millia Davenport Award from the Costume Society of America. **Fred Dennis and Valerie Steele**

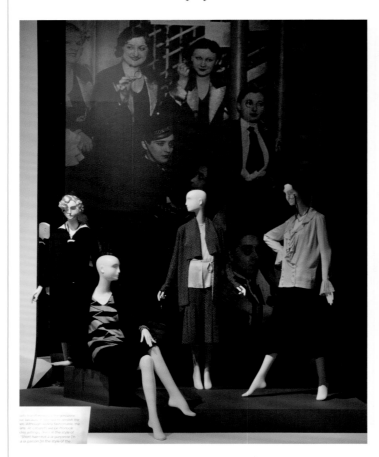

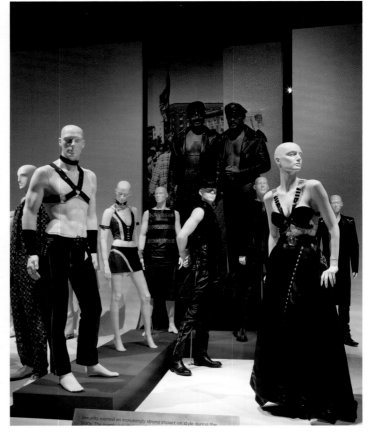

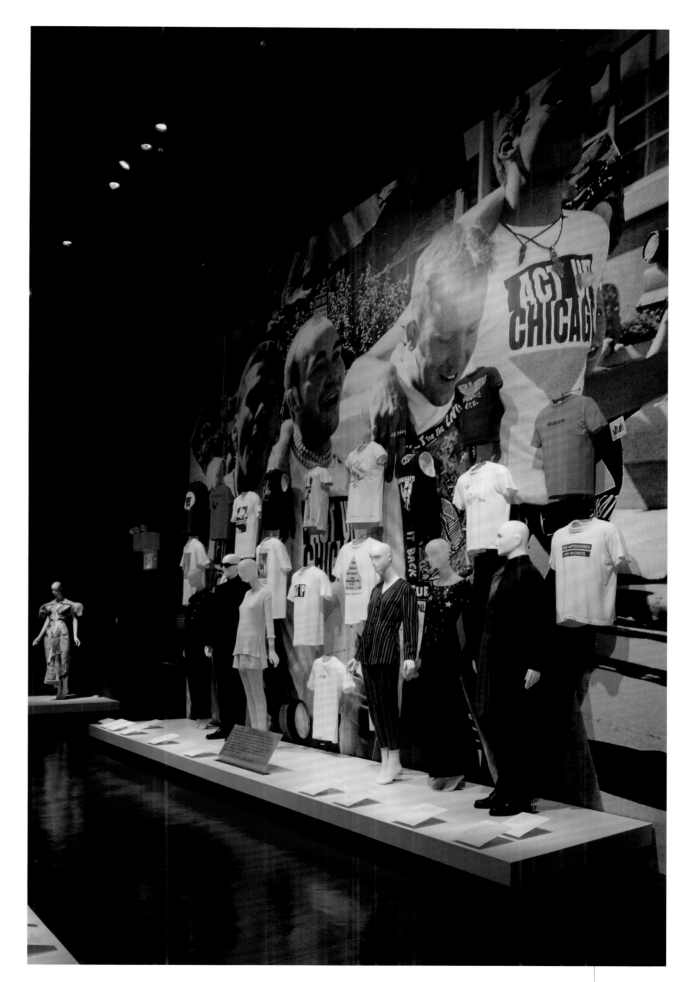

◄ Lesbian style influenced 1920s fashion

◄ Leather styles influenced 1990s designers such as Versace

► A memorial to designers who died during the AIDS crisis of the 1980s and 1990s, placed in front of a wall of AIDS activism T-shirts

Elegance in an Age of Crisis:
Fashions of the 1930s

February 7 – April 19, 2014
Curators: Patricia Mears and G. Bruce Boyer

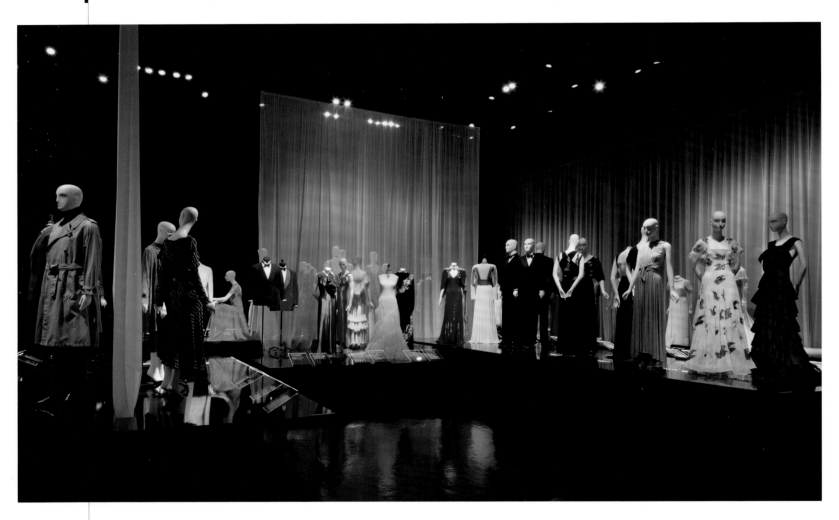

It is a compelling irony that the elegant and progressive qualities of 1930s fashions emerged during one of the most tumultuous periods of modern western history. Set between two horrific world wars—during a catastrophic economic depression— this decade was an era in which fashion exuded an especial elegance that sought inspiration from neo-classicism. From innovative craftspeople came beautifully proportioned silhouettes and streamlined styles that live on to this day as the ideal of modernity. *Elegance* simultaneously presented women's high fashion and bespoke menswear from Paris and London (capitals of haute couture and bespoke tailoring respectively), as well as Naples, New York, Los Angeles, Havana, and Shanghai. In addition to an array of evening gowns and suits, the exhibition offered a range of occasion-specific garments that were produced with increasing variety and innovation during the 1930s. Included were sports clothes that were lighter, more functional, and body-revealing, lingerie and at-home ensembles that resembled sensuous evening gowns and suits, and resort wear. **Patricia Mears**

◀ The exhibition featured menswear (left), women's daywear, Hollywood costumes, and elegant neoclassical gowns (right)

▼ The introductory gallery included accessories, such as shoes worn by Fred Astaire

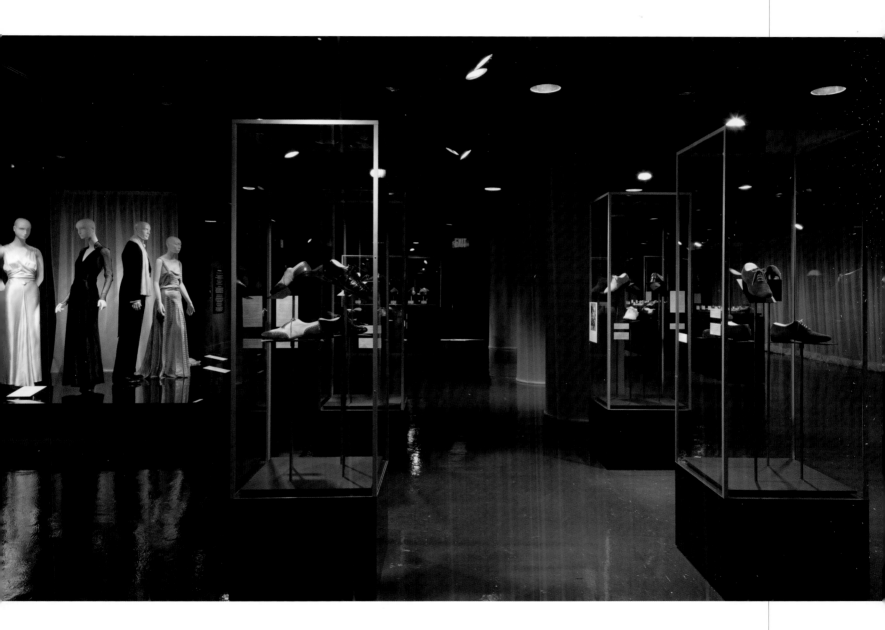

▼ Couture evening wear (left) by designers such as Balenciaga, Chanel, and Vionnet showcased the exquisite subtlety of women's fashion

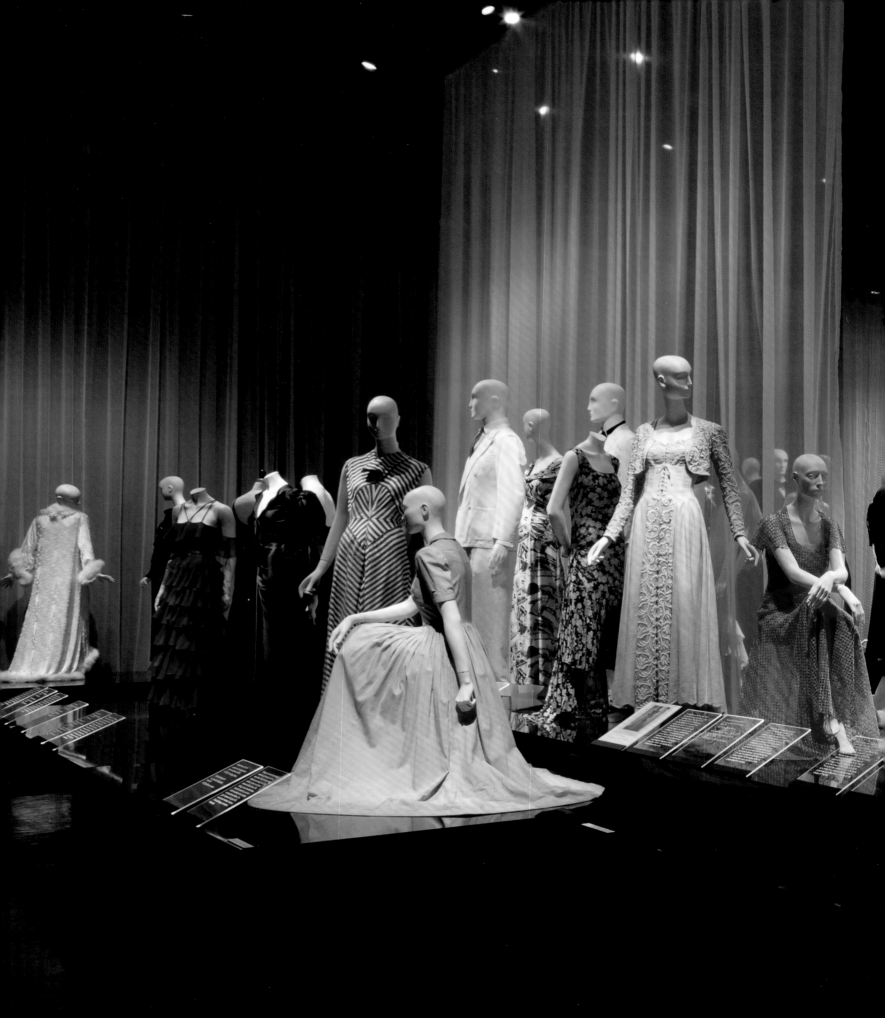

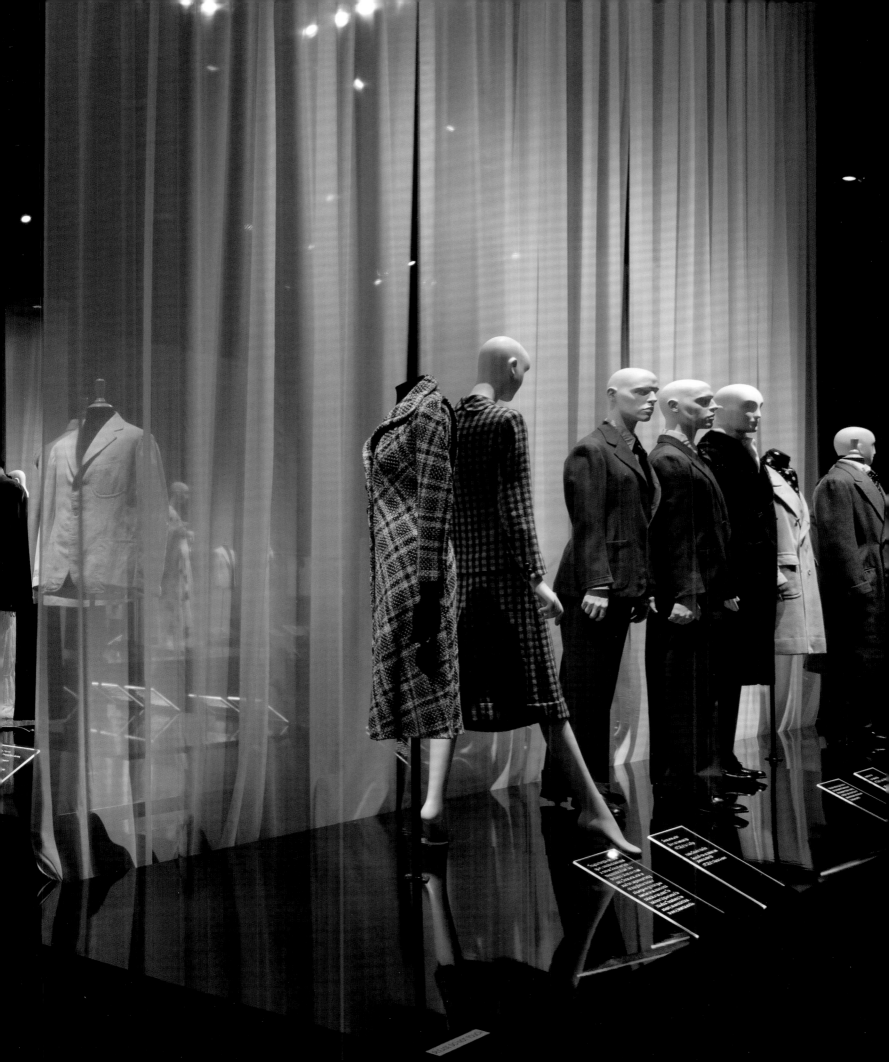

Faking It: Originals, Copies, and Counterfeits

December 2, 2014 – April 25, 2015
Curator: Ariele Elia

Fake designer goods may seem like a twenty-first-century phenomenon, but problems with counterfeit fashion go back as far as the nineteenth century. *Faking It: Originals, Copies, and Counterfeits* examined the myriad ways in which designers have tried—and sometimes failed—to protect their work. Originals and their copies were often placed side by side, allowing visitors to examine how subtle distinctions such as the quality of fabric, the stitching of a seam, or the placement of a zipper can differentiate an authentic item from its replica.

Yet not all copies are fakes: especially during the mid-twentieth century, when French couture reigned supreme, major U.S. department stores such as Bergdorf Goodman purchased the rights to make copies of 80 to 100 couture garments each season. Skillfully made by the store's seamstresses, these licensed copies provided more women with access to high fashion, while simultaneously allowing couturiers some control over the dissemination of their work.

Faking It provided a comprehensive exploration of a topic that is often misunderstood or simply ignored, and expanded understanding of how the fashion industry operates. **Colleen Hill**

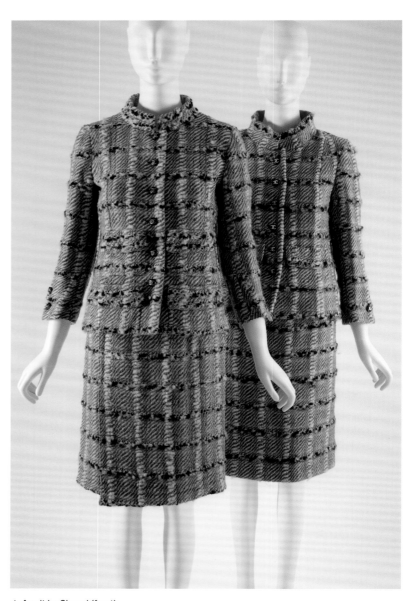

▲ A suit by Chanel (front) and a Chanel copy, 1966

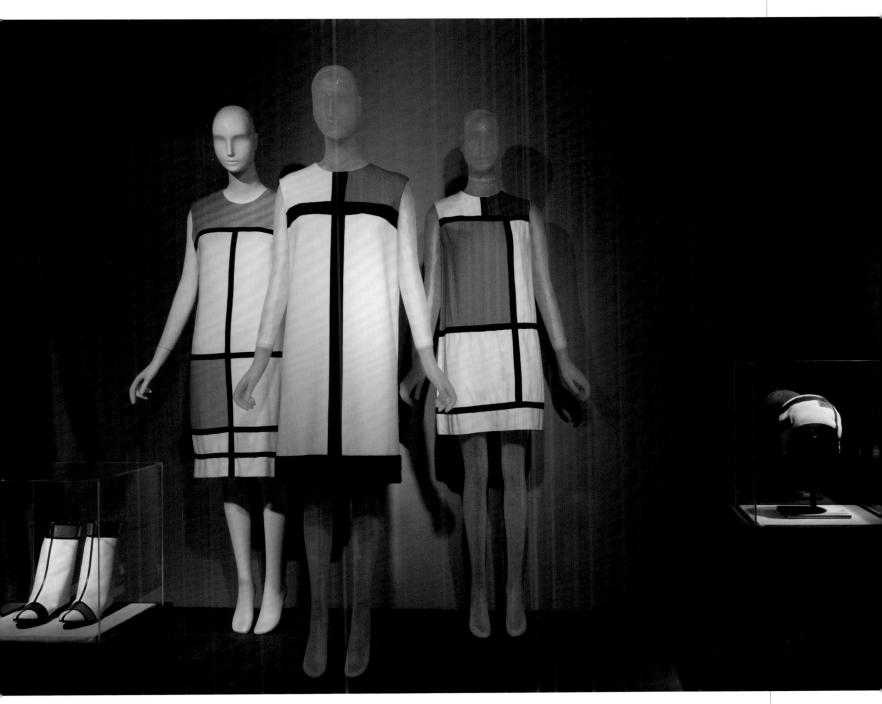

▲ Clothing and accessories
inspired by Mondrian's grid
paintings

Yves Saint Laurent + Halston: Fashioning the 70s

February 6 – April 18, 2015
Curators: Patricia Mears and Emma McClendon

Yves Saint Laurent and Halston were superstar fashion designers who dominated the 1970s. This exhibition, displaying objects drawn solely from The Museum at FIT's permanent collection, was the first to juxtapose their work.

The 1970s was a time of momentous change in fashion. Haute couture was diminishing, while designer-led conglomerates were on the rise. Wearing vintage and "ethnic" clothing were first-time trends coinciding with an increasingly relaxed dress code.

At the onset of the 1970s, Saint Laurent and Halston designed numerous garments that were remarkably similar; perhaps this parity was crucial to their maturation as designers. Eventually, the distinctive hallmarks of each designer emerged, such as Saint Laurent's brilliant use of color, drama, and fantasy, and Halston's unparalleled mastery of modernism and minimalism.

The exhibition also presented lesser known aspects of their careers. Saint Laurent's ready-to-wear Rive Gauche line became the starting point for his legendary couture, for example, while Halston, who was well-known for his many licensed products, was in fact an innovator of couture quality construction. Not a retrospective, the exhibition was a curatorial exploration and re-evaluation of two leading creators during the dreamy, indolent, sexy 1970s. **Patricia Mears**

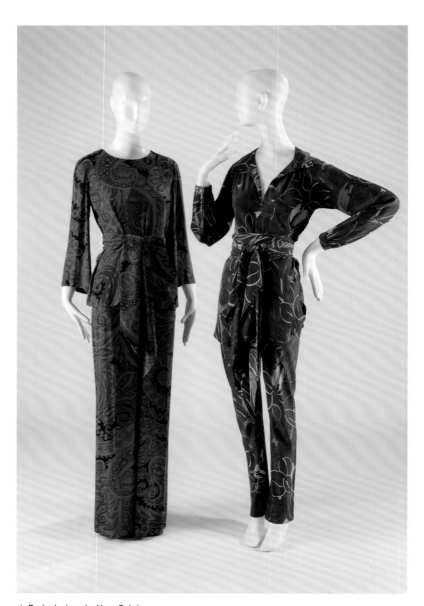

▲ Early designs by Yves Saint Laurent (left) and Halston (right) could be surprisingly similar

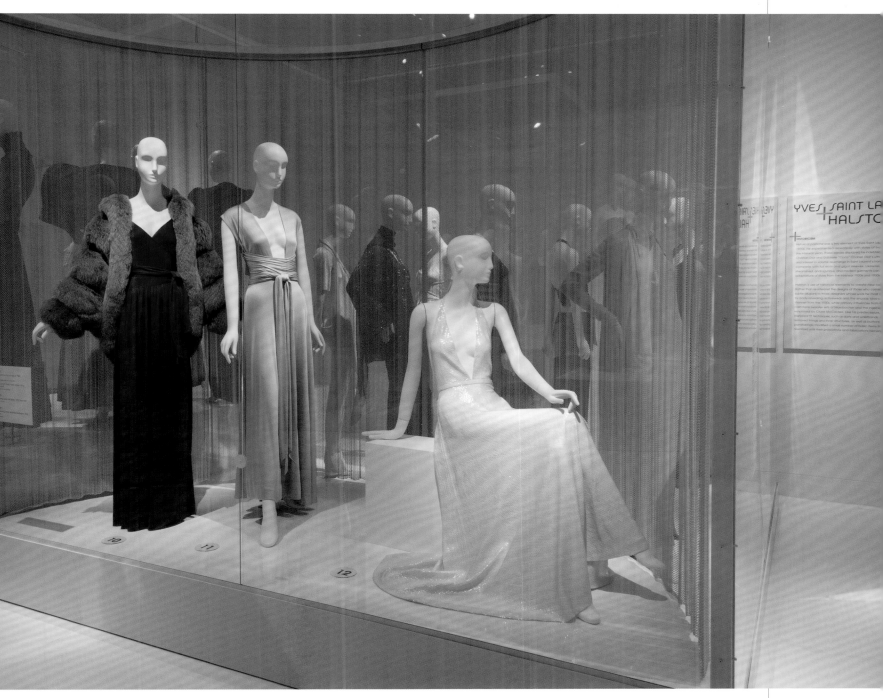

▲ A selection of Halston's silk jersey gowns

▼ Gleaming, white vinyl walls and floors evoked 1970s glamour

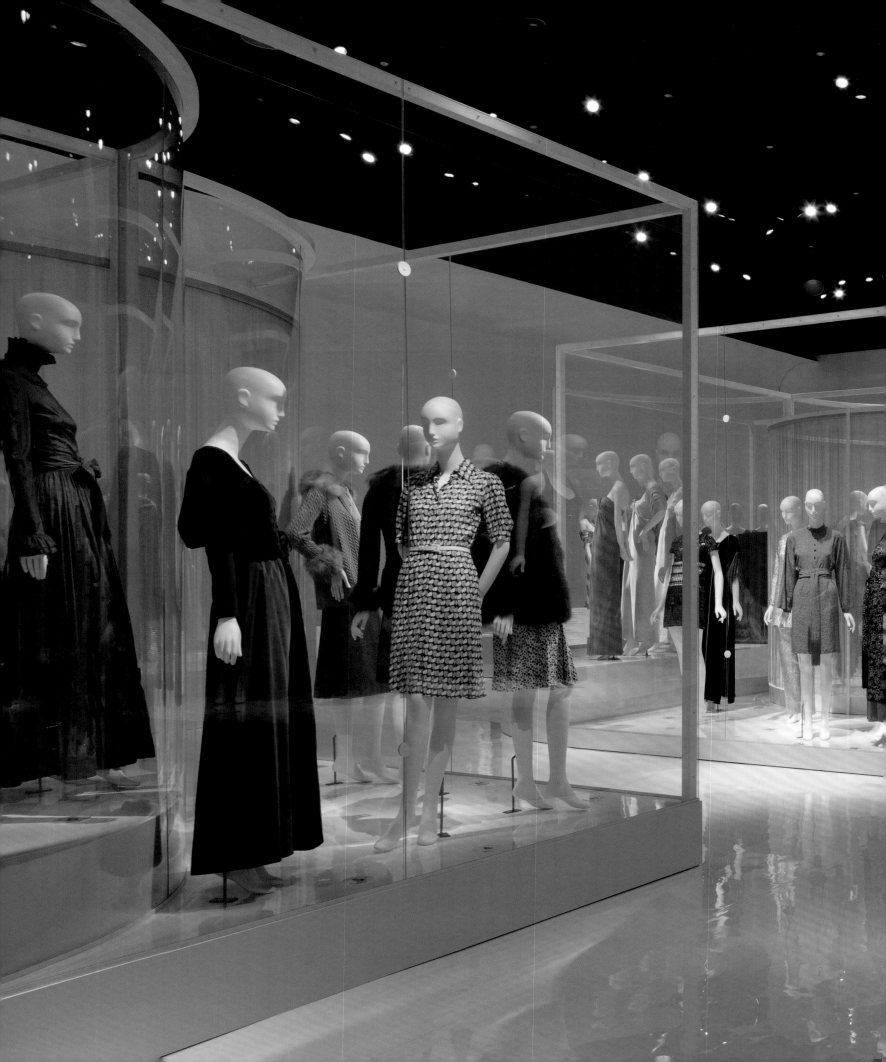

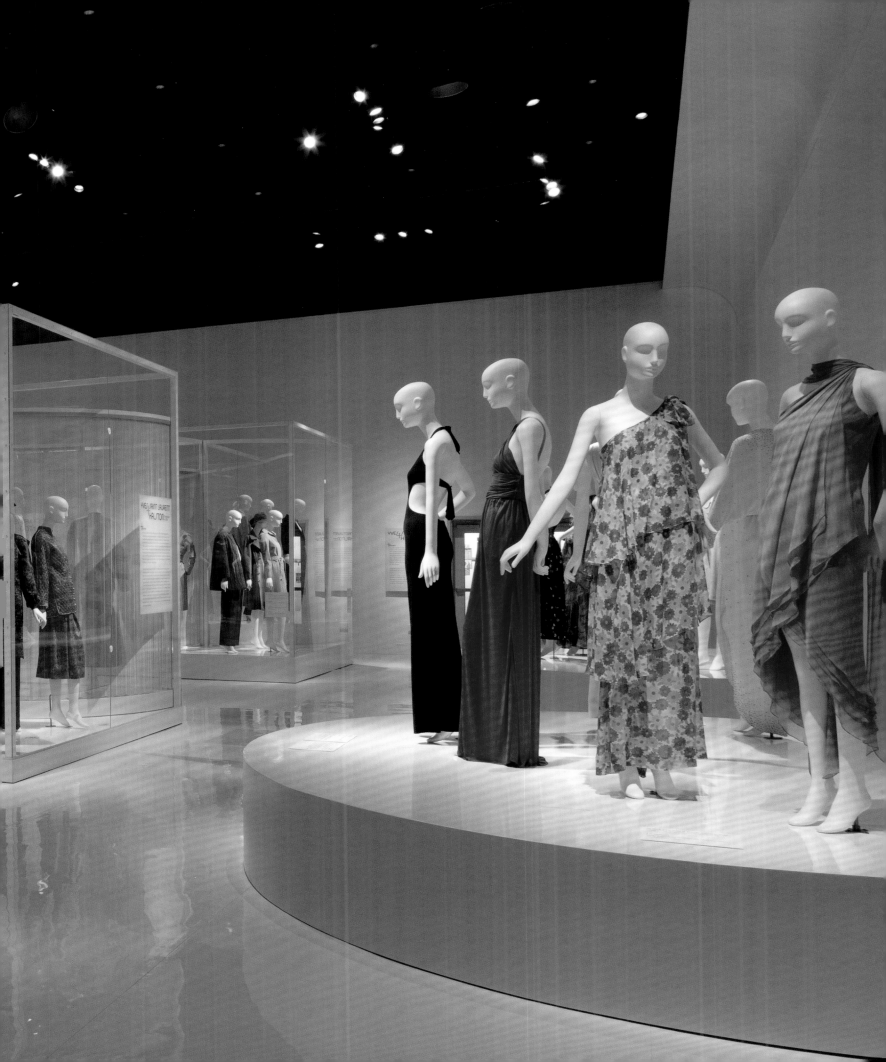

Global Fashion Capitals

June 2 – November 14, 2015
Curators: Elizabeth Way and Ariele Elia

During the first decades of the twenty-first century, "fashion week" became a worldwide phenomenon. Cities around the world eagerly invested in fashion industries, hoping to enhance their economies, build reputations of sophistication and modernity, and invite positive global attention.

Within this climate of international growth, *Global Fashion Capitals* examined twenty fashion cities, from the uncontested leaders—Paris, New York, Milan, and London—to acknowledged centers in Tokyo and Antwerp, to the exciting emerging industries in Stockholm/Copenhagen, Berlin, Moscow/St. Petersburg, Kiev, Istanbul, Madrid, Mexico City, São Paulo, Johannesburg, Lagos, New Delhi/Mumbai, Seoul, and Shanghai.

Selecting the emerging cities was a daunting task for the curators, whose research relied on international fashion press and interviews with experts from around the world. Ultimately, they collected pieces from designers who created internationally appealing styles that also spoke to their localities. Lisa Folawiyo of Lagos, Nigeria, for example, re-conceptualized traditional African fabrics for her modern, fringe-beaded sheath. The exhibition helped expand the idea of where fashion can originate, and enhanced the diversity of MFIT's permanent collection. **Elizabeth Way**

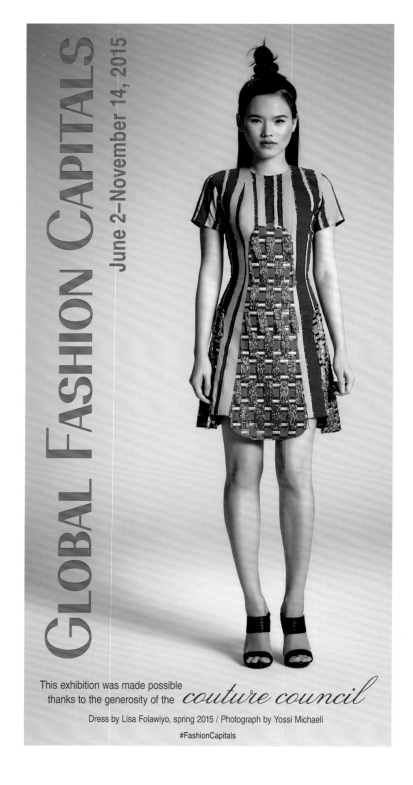

GLOBAL FASHION CAPITALS
June 2–November 14, 2015

This exhibition was made possible thanks to the generosity of the *couture council*

Dress by Lisa Folawiyo, spring 2015 / Photograph by Yossi Michaeli
#FashionCapitals

◄ *Global Fashion Capitals*
window graphic. Lisa Folawiyo,
dress, Lagos, Nigeria, spring 2015

▶ Big Park, dress, Seoul, Korea,
spring 2015

Denim: Fashion's Frontier

December 1, 2015 – May 7, 2016
Curator: Emma McClendon

Denim: Fashion's Frontier challenged the typical narrative of denim's history—one that traditionally equates denim with blue jeans and American masculinity, erasing the impact denim has had on women's fashion beyond jeans.

Although denim has become a mainstay of high fashion runways in recent years and carries intricate layers of cultural meaning, it is first and foremost a workwear fabric. As a result, people historically did not often consider denim important enough to keep and preserve.

This makes the considerable collection of over 200 denim objects at The Museum at FIT all the more significant. The museum's denim garments include nineteenth-century men's trousers, a nineteenth-century woman's workwear jacket, and a prisoner uniform from 1913. The majority of this rare and impressive holding came into the museum's collection during Richard Martin's tenure as director. Martin was a pioneer in the scholarly study of fashion with a strong interest in the socio-political power of clothing. Several of the most significant denim pieces were donated by him personally. **Emma McClendon**

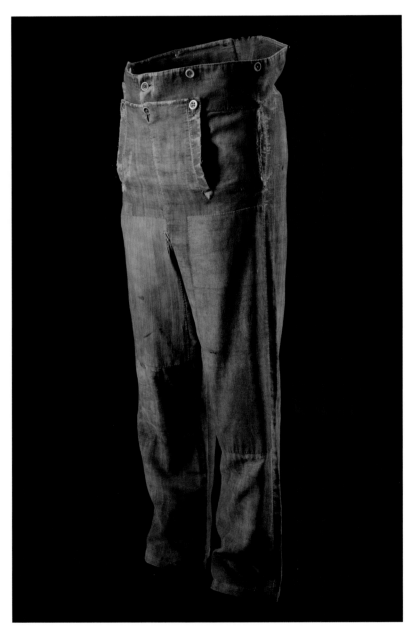

▲ An early example of patched denim trousers, USA, c. 1840

▶ Roberto Cavalli, eighteenth-century-inspired ensemble, Italy, 2002–03

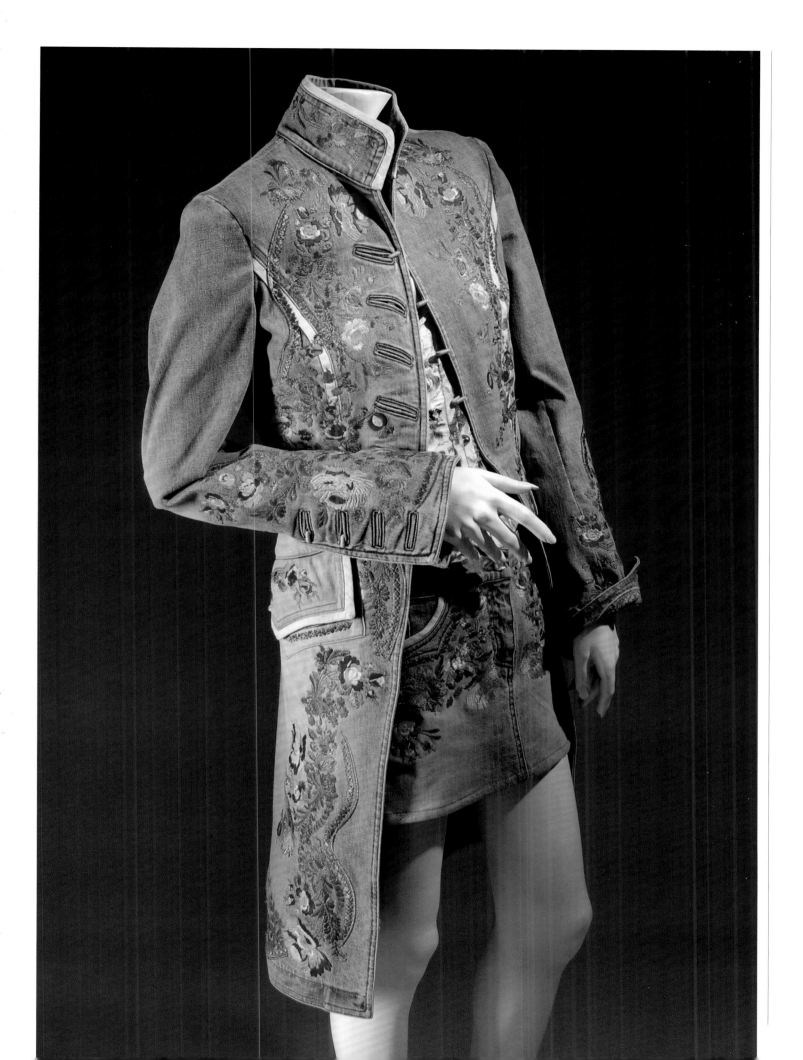

Fairy Tale Fashion

January 15 – April 16, 2016
Curator: Colleen Hill

Many fashion designers tell stories through their work, and curators sometimes consider their practice to be a form of storytelling. These ideas came together in *Fairy Tale Fashion*, an imaginative exhibition that illustrated fifteen classic literary fairy tales using clothing and accessories. Each of the tales—based on the work of prominent writers such as Charles Perrault, Jacob and Wilhelm Grimm, Hans Christian Andersen, and Lewis Carroll—was selected for its direct references to clothing or its mention of important recurring motifs, such as blonde hair or red roses.

The garments were placed in floor-to-ceiling *mise-en-scène* inspired by early fairy tale illustrations and designed by architect Kimberly Ackert. Printed scrims depicted archetypal settings, including the forest and the sea, while a castle structure loomed in the center of the gallery. Unexpected juxtapositions—such as a mid-eighteenth-century French court gown shown alongside a 2007 dress from the Los Angeles-based label Rodarte—underscored that fairy tales are rarely set in a particular place or time. The exhibition drew large crowds, and was especially appealing to young children, many of whom dressed in princess costumes.

Colleen Hill

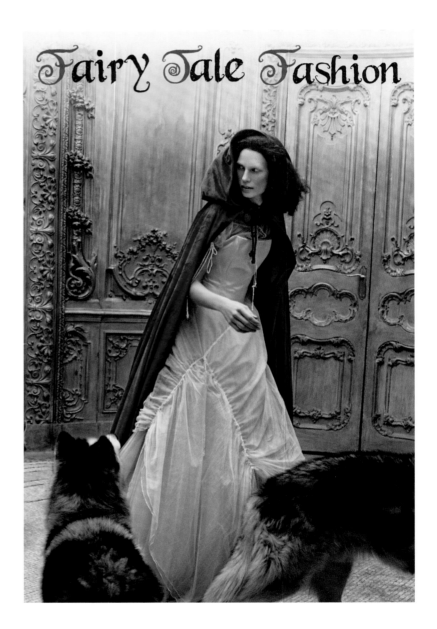

◄ The cover of the *Fairy Tale Fashion* exhibition brochure, featuring a photograph by Eugenio Recuenco

▼ Ensembles illustrating *Little Red Riding Hood*

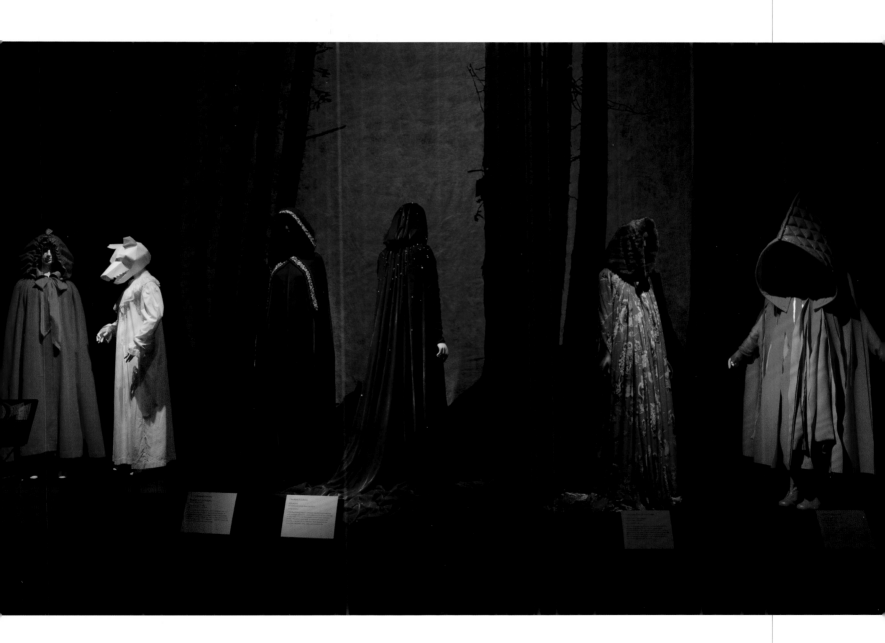

Black Fashion Designers

December 6, 2016 – May 16, 2017
Curators: Elizabeth Way and Ariele Elia

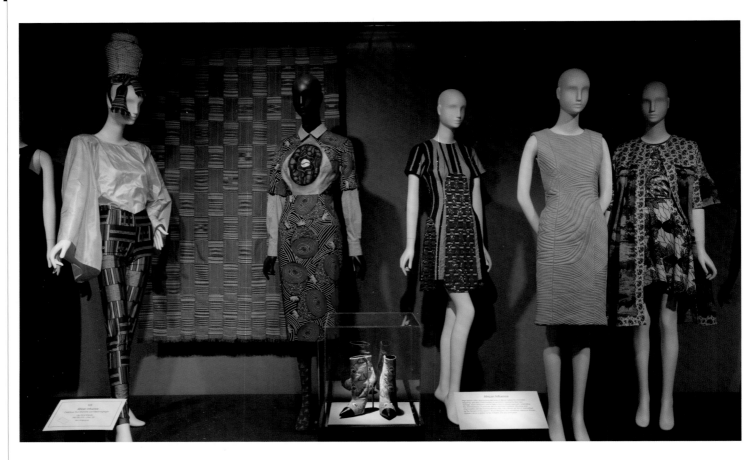

In 2016, black designers represented only 1% of the designers covered by the mainstream fashion press, despite the many diasporic designers working in international fashion industries. Black designers are often pigeonholed by the press, fashion buyers, and others searching for a monolithic "black style." *Black Fashion Designers* challenged this erasure and stereotyping by presenting work by more than sixty black designers, contextualizing their broad range of talent within the fashion industry.

Black Fashion Designers was the most comprehensive exhibition of black fashion design to date. It expanded on MFIT's 1992 show, *Tribute to the Black Fashion Museum*, in which curators Richard Martin and Harold Koda collaborated with Harlem's Black Fashion Museum and its director, Lois Alexander, to feature the work of thirty-seven African American fashion designers.

Black Fashion Designers was enriched by the expertise of its advisory committee of prominent fashion professionals. Audrey Smaltz, a groundbreaking model during the 1950s and former fashion editor for *Ebony*, donated garments from her private collection, including rare mid-twentieth century designs by Jon Weston and Wesley Tann. Another committee member, journalist André Leon Talley, lent his recognizable voice as narrator to the exhibition's multimedia mobile tour. The tour, a first for MFIT, enhanced the exhibition experience with designer interviews, archival images, and videos. **Elizabeth Way**

◀ The "African Influence" section explored the impact of African aesthetics on black designers

▶ Scott Barrie, dress, USA, circa 1973

Paris Refashioned, 1957–1968

February 10 – April 15, 2017
Curator: Colleen Hill

Dispelling popular myths is sometimes part of a fashion curator's job. *Paris Refashioned, 1957–1968* aimed to inform visitors that while London is often considered the epicenter of 1960s fashion, Paris continued to play a significant, yet often overlooked role in the fashion industry. It was during this era that *prêt-à-porter* (ready-to-wear) came into its own, led by a group of young, innovative women including Gaby Aghion (the founder of Chloé), Emmanuelle Khahn, and Sonia Rykiel. Traditionally-trained couturiers also recognized the changes taking place in the fashion industry, and by the second half of the 1960s, Pierre Cardin, André Courrèges, and Yves Saint Laurent had created young styles and established successful ready-to-wear lines.

MFIT houses a rare and significant collection of both couture and ready-to-wear from this era, much of which had never before been on view. *Paris Refashioned*, designed by Kimberly Ackert, was divided into two spaces: the first, elegantly designed to resemble a couturier's *atelier*, featured only couture fashions from 1957 to 1960. The larger gallery space was devoted to fashions from 1961 through 1968. The vibrant, youthful clothing—a juxtaposition of couture and ready-to-wear—was echoed by a colorful exhibition design evocative of a Paris streetscape. **Colleen Hill**

▲ Emmanuelle Khanh, dress, France, 1966

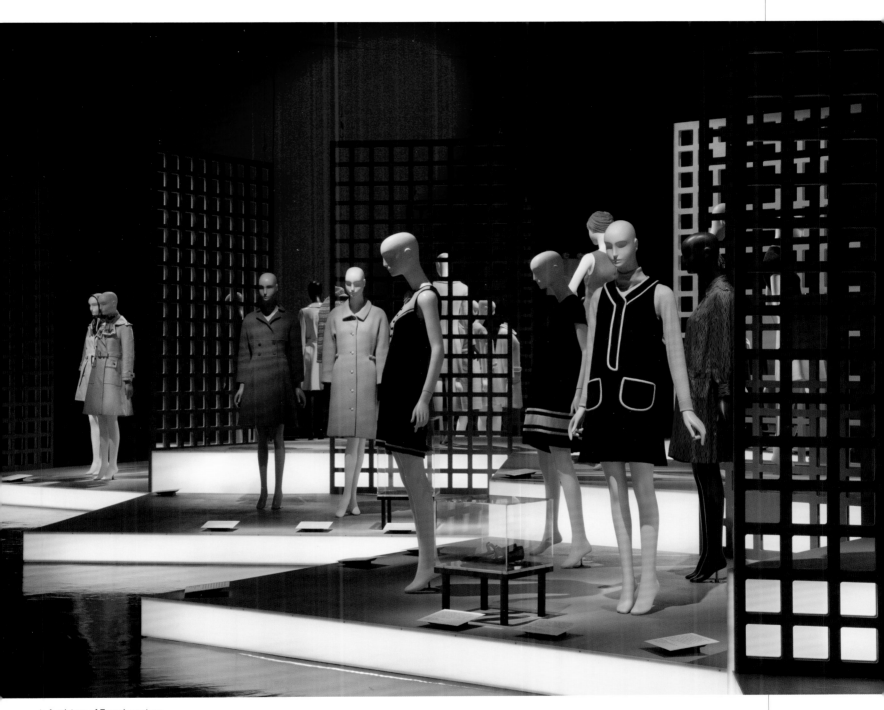

▲ A mixture of French couture
and ready-to-wear garments
dating from 1961 to 1968

Force of Nature

May 30 – November 18, 2017
Curator: Melissa Marra

Force of Nature examined how the beauty and complexity of the natural world has inspired fashion. Although nature has for centuries inspired the arts, including fashion, we often think of natural science and art as unconnected disciplines. In truth, they have long influenced one another.

The exhibition was organized into ten sections, each highlighting a facet of the complex relationship between fashion and the natural sciences. Sections such as "The Botanic Garden," "The Science of Attraction," and "Physical Forces," examined the appeal of scientific discoveries that found expression not only in books, but also through clothing and textiles. Other sections such as "The Aviary" and "Metamorphosis" highlighted symbolic associations between fashion and nature. Nature sounds and videos helped to create an immersive atmosphere, while specially designed digital media offered additional information about science topics covered throughout the exhibition.

Melissa Marra

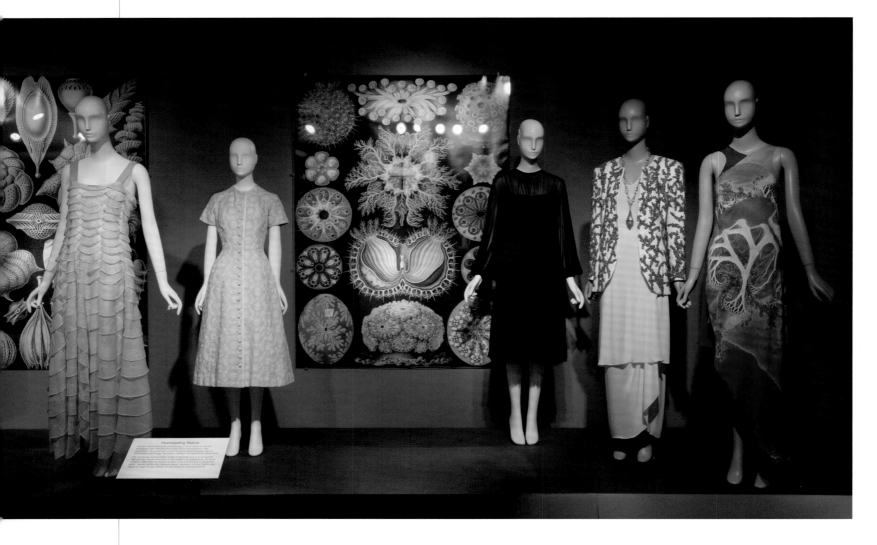

◄ Installation view of the
"Investigating Nature"
section, highlighting fashion's
appropriation of forms and
patterns found in nature

▼ *Tree* dress with *Petal*
stole by Charles James (1955)
and a cutwork lace dress
(c. 1905), featured in the
"Language of Flowers" section

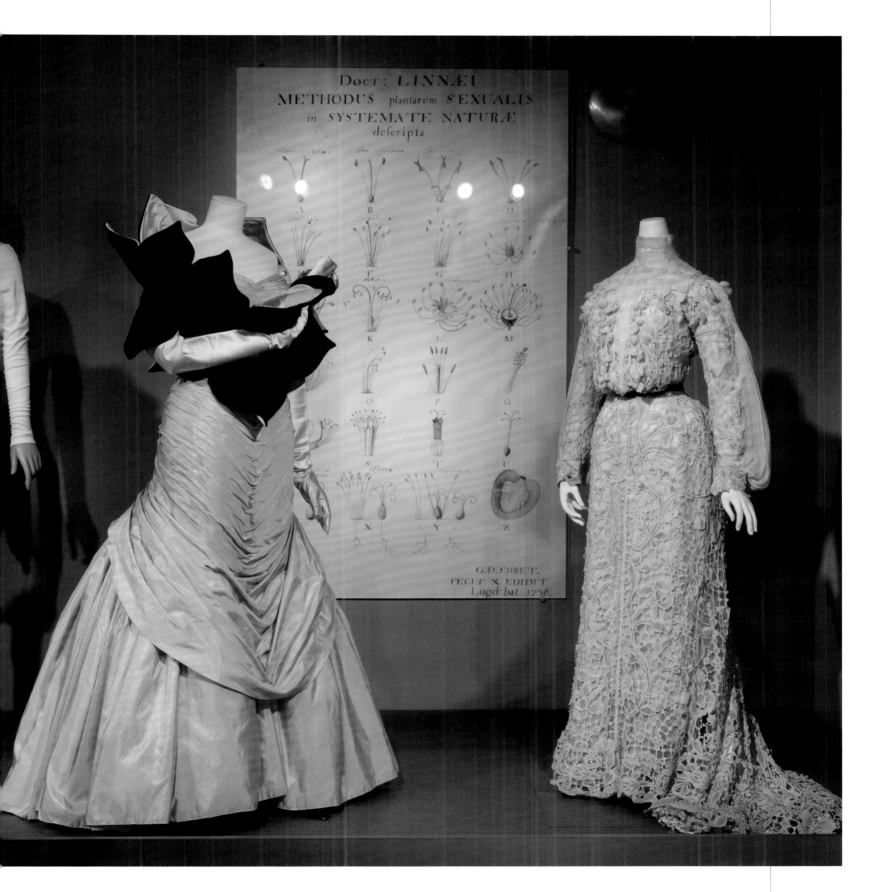

Expedition: Fashion from the Extreme

September 15, 2017 – January 6, 2018
Curator: Patricia Mears

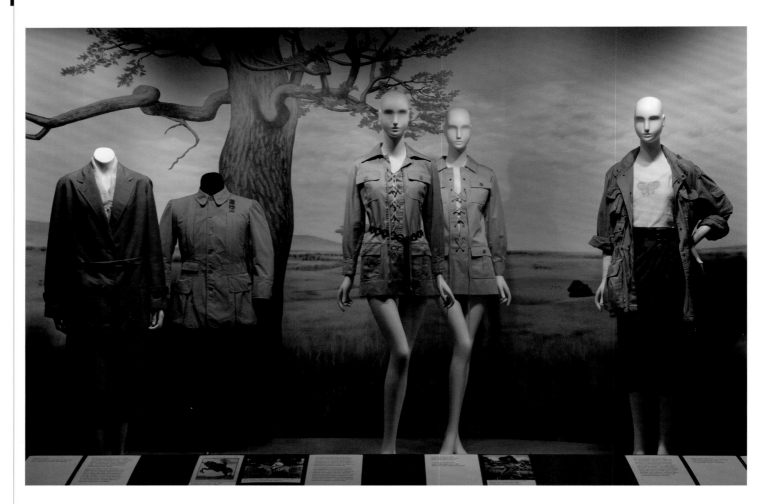

Expedition was the first large-scale exhibition to examine the influence of clothing developed for survival in brutally harsh environments on high fashion. It showed how quests to reach the North and South Poles, scale the highest mountain peaks, plumb the ocean depths, and travel to outer space stimulated designers to create spirited versions of Arctic furs and parkas, down-filled outerwear, space age jumpsuits, and deep sea diving suits.

Travel to these extreme destinations paralleled the rise of science during the Victorian era, as interest in the natural world flourished. Extreme expeditions were celebrated, newsworthy events as early as the mid-nineteenth century, yet fashionable clothing reflecting those influences was rare prior to the 1960s. Modern and contemporary ensembles were placed within "extreme environments" designed for the museum's galleries, evoking both

the beauty and the dangers of these locales. Many of the garments were fanciful, illustrating how designers were enthralled by technologies used by expeditioneers, from the ancient innovations of the Arctic peoples to latest space age materials. Others reflected a growing awareness of the human impact on the earth's fragile ecosystem. **Patricia Mears**

◀ Dioramas such as those in natural history museums inspired the design of the "Safari" section

▼ Dramatic lighting and sets, including icebergs, seascapes, and spacecraft, created other-worldly environments that wowed visitors

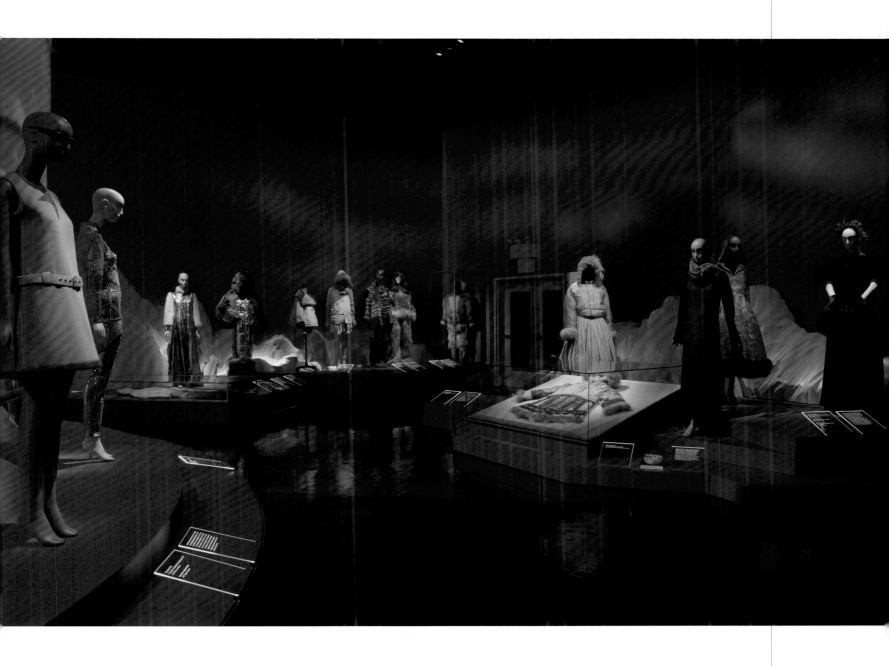

▼ The "spaceship" featured 1960s Space Age fashions and later iterations, including Hussein Chalayan's 2000 *Airplane* dress (center)

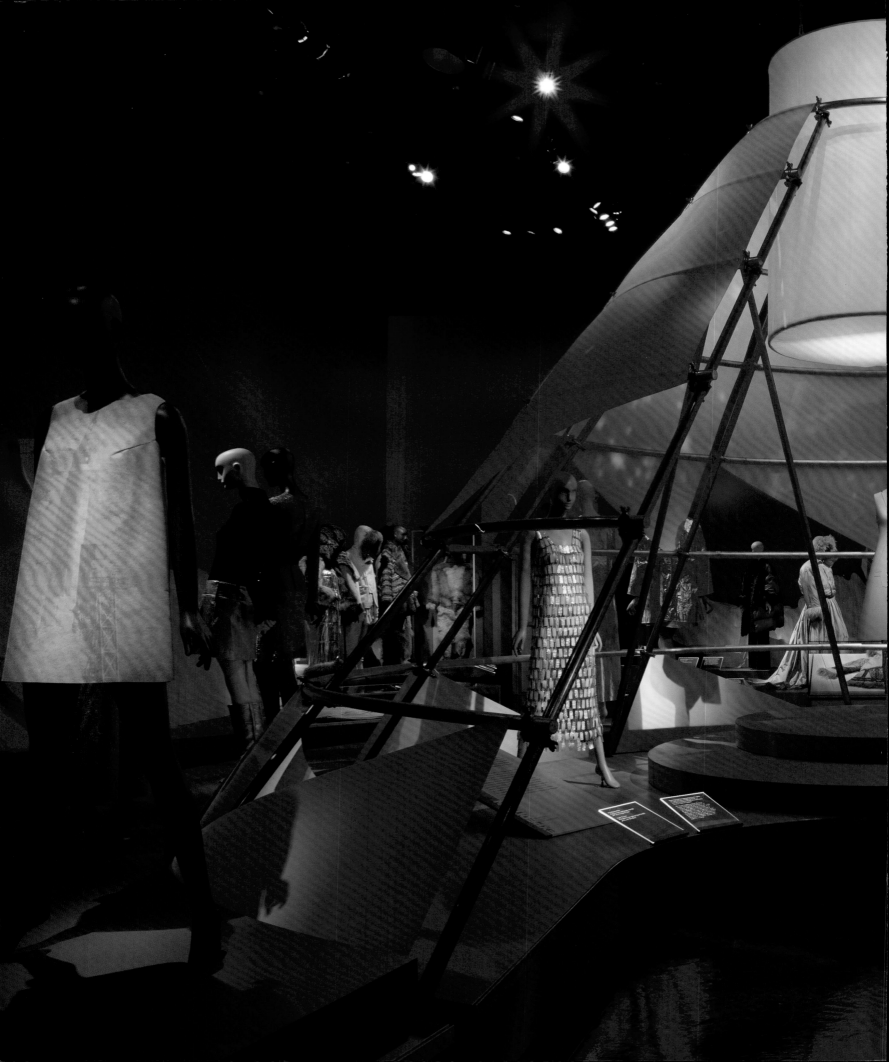

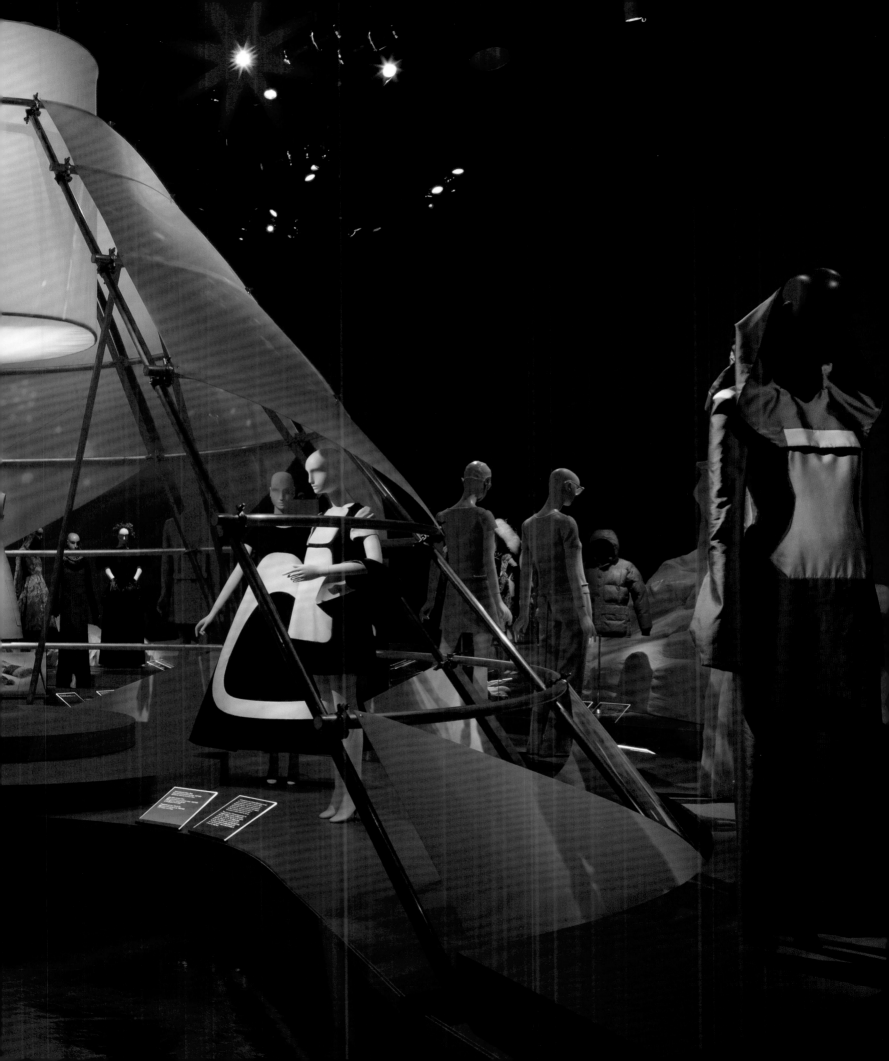

The Body: Fashion and Physique

December 5, 2017 – May 5, 2018
Curator: Emma McClendon

The Body explored the complex relationship between the fashion industry and body politics from the eighteenth century to the present. Taking current conversations on body positivity and the lack of diversity in fashion as a starting point, the exhibition included not only garments, but also videos of designers, models, scholars, and activists to help visitors understand the ways certain body types are validated within fashion at the expense of others.

Central to the exhibition was the uncomfortable fact that the fashion industry has historically treated the body (particularly the female body) as malleable and imperfect.

A "fashionable" body must be shaped and maintained through the use of foundation garments, diet, exercise, and even plastic surgery, depending on the period. Sadly, this attitude—that our natural selves are not good enough—permeates our culture's collective psychology. As Laird Borrelli of *Vogue* observed, "Perhaps the most important takeaway from this exhibit is that while codified ideals of beauty exist, the only real way to free the fashionable body is first to free our minds." Emma McClendon

▲ Chromat (Becca McCharen-Tran), ensemble originally made for plus-size model Denis Bidot, USA, spring 2015

▲ Maison Martin Margiela, tunic (center), 1997, in a display highlighting the changing shape of dress forms

Fashion Unraveled

May 25 – November 17, 2018
Curator: Colleen Hill

Fashion Unraveled was not a typical fashion exhibition. Rather than focusing on pristine clothing that exemplified a theme, a time period, or a designer's aesthetic, the exhibition examined the concepts of memory and imperfection in fashion. Garments that had been mended, altered, left unfinished, or deconstructed took precedence. The curatorial selections were made to highlight one elemental fact about clothing: that it is designed to be worn and has, in some cases, been worn out.

Many garments show traces of wear or alterations, but those with visible flaws tend to be overlooked within museum collections. If they are selected for exhibition, curators rely on the expert work of a conservator, a gallery's low lighting, or strategic placement to disguise imperfections. *Fashion Unraveled* chose to highlight the changes made to these garments, illuminating their unique histories. The exhibition was accompanied by the museum's first major crowdsourced initiative, "Wearing Memories." Participants were asked to share the story and photos of a garment that holds special meaning to them. More than 300 entries were received. While a small selection of the stories was highlighted in a video within the exhibition, many more entries were featured online. The project underscored the deeply personal relationships we sometimes have with our clothes. **Colleen Hill**

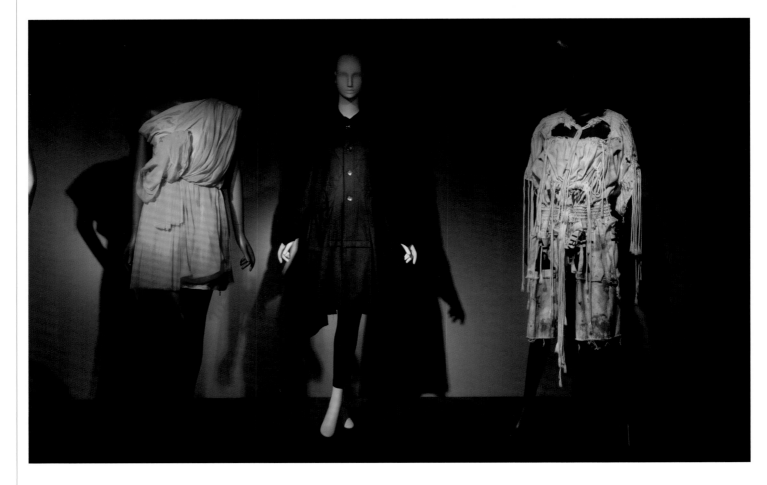

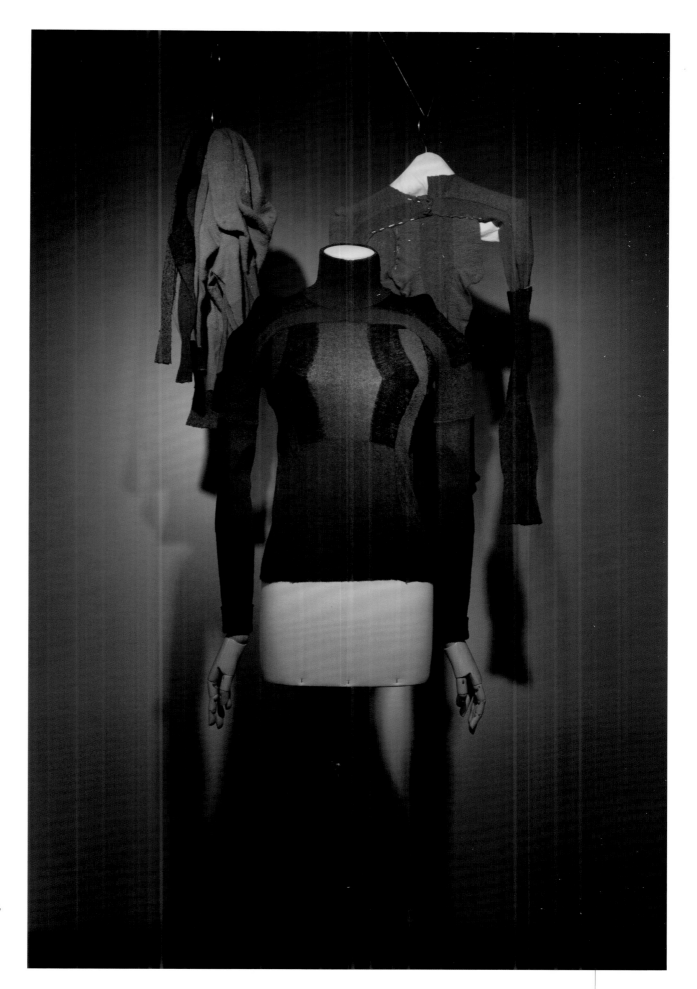

◀ Garments highligting
the deconstructed aesthetic,
by Lanvin (left), Junya Watanabe,
and Bernhard Willhelm

▶ Maison Martin Margiela's
"sock sweater," 1991, shown
in various phases of completion

The Culture of Learning at MFIT

Education has been pivotal to the development of The Museum at FIT since its inception in 1969 as the Edward C. Blum Design Laboratory. Educational strategies have evolved for five decades, progressing from an emphasis on individual contact with objects, to exhibition-centered learning and the building of intercultural and interpersonal bridges, creating experiences that establish the museum as a place of engagement, insight, and discovery.

In its early years, the Design Laboratory gave students and members of the industry access to the collections and allowed them to handle objects. During the 1980s and 1990s, under the leadership of Richard Martin, MFIT focused increasingly on "education emanating from exhibitions."[1]

When Dr. Valerie Steele became director, she continued to enhance exhibitions and initiated public programs that would make the museum a center of fashion studies. MFIT established its fashion symposia series, which brings together academics, members of the fashion industry, and designers to expand on topics addressed by MFIT exhibitions. The Fashion Culture Program is a series of lectures, films, panel discussions, and exhibition tours. Another educational innovation was the Fashion and Textile History Gallery, in which MFIT utilizes its permanent collection to create thematic exhibitions. Steele determined that this gallery would provide students with "a dramatic visual impression of social, cultural, and aesthetic change" in fashion.[2]

In 2010, MFIT established an education department with Tanya Melendez-Escalante as senior curator of education and public programs. Her vision was to help the museum become a space of reflection, inspiration, and inquiry that engages the community at large. Building on the Fashion Culture series and symposia, the museum expanded its offerings to include international workshops, school and family programs, and collaborations with the FIT community. Today, the education team also includes Julian Clark, publications coordinator, Faith Cooper, education assistant, Eileen Costa, photographer, and Melissa Marra-Alvarez, curator of education. They work together to create publications, programs, and other educational initiatives with the goal of inciting joy and learning.

Two projects that exemplify this vision are the Cross-Pollination Workshop and the local elementary school program. In the workshops, college-level students work long distance with peers in another country across social media. The museum and its collections are the meeting point at which young adults can exchange experiences and work together to produce a common project that incorporates their diversity.

For the school program, museum educators work with the kindergarten teachers at P.S. 33 Chelsea Prep to develop a curriculum for young learners so that the children become empowered museum visitors. For fifty years, flexibility has been key to bringing together the voices of academics, creators, and industry professionals from diverse backgrounds and perspectives. It is this juxtaposition of varied and contrasting viewpoints that awakens the imaginations of visitors. The museum is thus a living space that invites an exchange of knowledge, fostering critical dialogue about fashion and its impact on the human experience. **Faith Cooper and Tanya Melendez-Escalante**

[1] Special Collections & College Archives, letter by Richard Martin, October 9, 1986, Fashion Institute of Technology, New York, NY.
[2] Valerie Steele, "Fashion History Gallery: Fashion as Part of History" (on-file at The Museum at FIT), 2010.

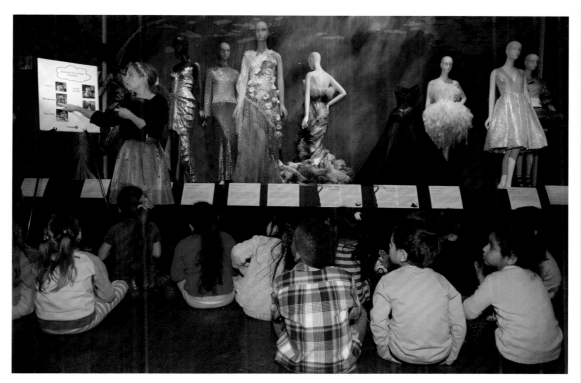

▲ Kindergarten students from
PS 33 Chelsea Prep visit MFIT
as part of the *Fairy Tale Fashion*
school program (2016)

▼ Steppers workshop organized
in conjunction with the *Dance
and Fashion* exhibition (2014)

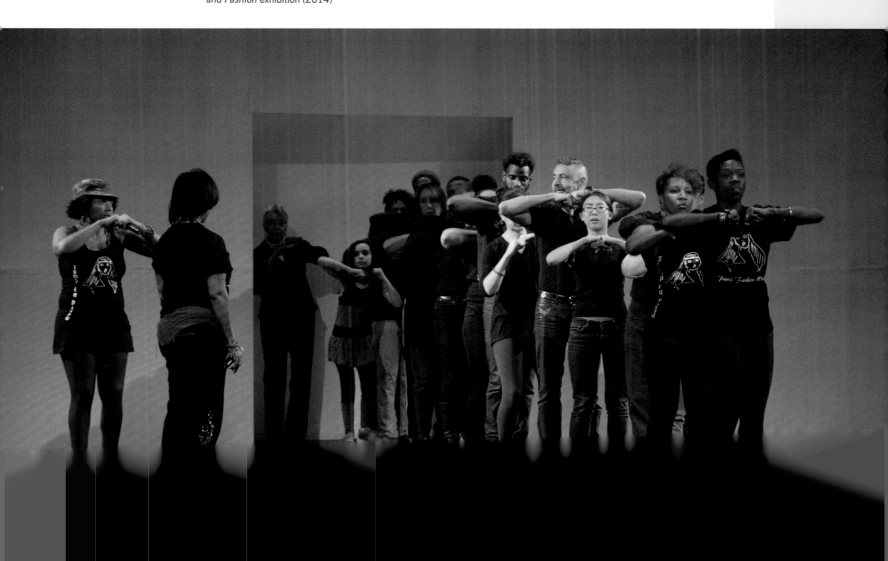

The Study Collection at The Museum at FIT

The fashion study collection at MFIT is a rare resource in a design school, currently holding over 1,000 costumes and accessories. Its objects date from the 1840s to the present, representing general fashion history. The study collection also prominently features renowned designers such as Chanel, Balenciaga, and Claire McCardell. Multiple departments at FIT at both the undergraduate and graduate levels integrate the use of study objects into their curricula. FIT and non-FIT graduate students working on Master's theses have the opportunity to individually view garments from the study collection, as well as the permanent collection, via research appointments. Members of the curatorial staff deliver a lecture on twentieth-century fashion that draws on the breadth of study collection objects. This one hour presentation of approximately twenty-five costumes and accessories tangibly illustrates the historical evolution of women's mobility—both socially and physically—through fashion, from the rise of the corset in the mid-1850s to the shift to pants as evening wear in the 1970s. The lecture also motivates students to reflect on the reactivation of historical silhouettes and motifs in contemporary fashion and encourages them to question the use of historicism today. These comparisons denote how extant fashion garments can be effectively used to teach history, particularly themes such as gender roles, women's rights, fashion production, and the emergence of ready-to-wear.

The collecting policy for permanent collection pieces focuses on aesthetically and historically significant fashion, with an emphasis on contemporary avant-garde or "directional" fashion. For study pieces, the museum places a greater emphasis on garments that offer opportunities for tactile learning. We aim for the study collection to be inspirational, encouraging students to experiment with silhouettes, materials, and embellishments. The MFIT study collection also houses a unique selection of toiles, custom reproductions rendered in muslin. Due to the rarity or fragile state of certain historical garments, toiles

offer rare insight into the construction process, specifically in regards to patternmaking.

In a study collection, the make and wear of a garment are emphasized through hands-on interaction. If alterations have been made that disrupt the integrity of the original design, if the garment is suffering from severe condition issues, or if it is a duplicate of a permanent collection item, it may be considered for study. The educational value of a costume or accessory object is not dismissed due to deteriorating condition. On the contrary, exposure allows for a deeper understanding of aging processes, specifically regarding the degradation of synthetic versus natural materials. An object's unraveling state allows students to see how a garment was made, and it alludes to the experience of the former wearer. Exposed seams reveal layers of fabric and construction process. Stains and tears demystify the privileged position in which seemingly impeccable historical garments tend to be placed at museums. In permitting students to handle visibly used garments, we are promoting exposure to fashion objects in imperfect condition. **Michelle McVicker**

◀ Muslin toile replica of Paul Poiret's
Lampshade tunic, France, 1913
(detail)

▶ Pierre Balmain, *New Look*-inspired
suit, France, spring 1948

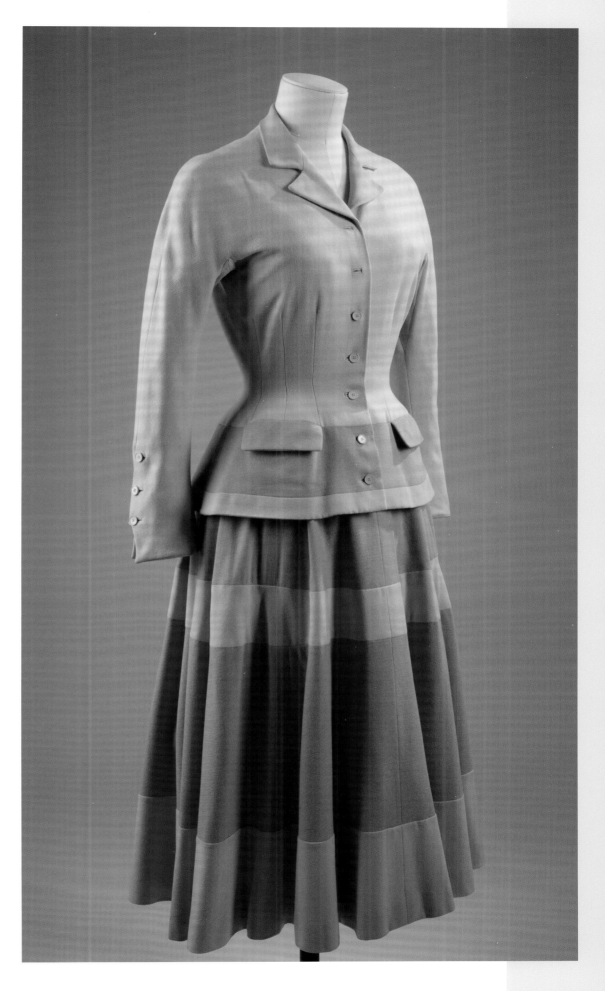